IMAGES
of America

ARAB AMERICANS
IN METRO DETROIT
A PICTORIAL HISTORY

D1500546

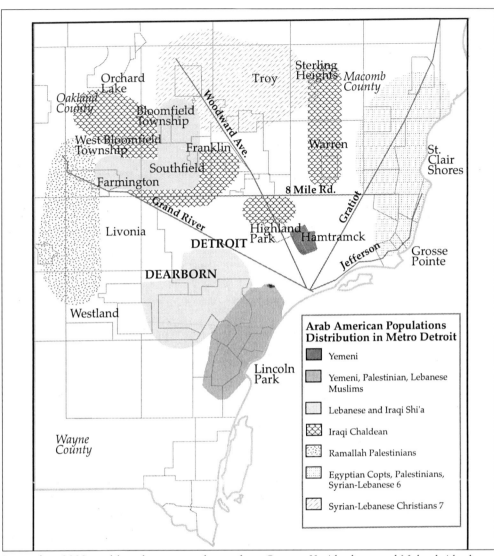

Arab American Populations Distribution in Metro Detroit

- Yemeni
- Yemeni, Palestinian, Lebanese Muslims
- Lebanese and Iraqi Shi'a
- Iraqi Chaldean
- Ramallah Palestinians
- Egyptian Copts, Palestinians, Syrian-Lebanese 6
- Syrian-Lebanese Christians 7

Revised in 2000, and based on original map from Sameer Y. Abraham and Nabeel Abraham, *Arabs in the New World* was published by Wayne State University of Detroit in 1983. The design was by Melinda Hamilton.

IMAGES
of America

ARAB AMERICANS
IN METRO DETROIT
A PICTORIAL HISTORY

Anan Ameri
Arab Community Center for Economic and Social Services

Yvonne Lockwood
Michigan State University Museum

ARCADIA

Published by Arcadia Publishing,
an imprint of Tempus Publishing, Inc.
3047 N. Lincoln Ave., Suite 410
Chicago, IL 60657

Printed in Great Britain.

Library of Congress Catalog Card Number: 2001093313

For all general information contact Arcadia Publishing at:
Telephone 843-853-2070
Fax 843-853-0044
E-Mail sales@arcadiapublishing.com

For customer service and orders:
Toll-Free 1-888-313-2665

Visit us on the internet at http://www.arcadiapublishing.com

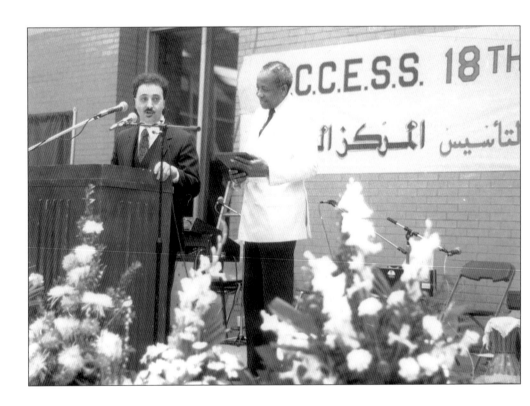

For further information about the Arab American community in metro Detroit call the Cultural Arts Program at the Arab Community Center for Economic and Social Services (ACCESS) (313) 843-2844.

CONTENTS

ACKNOWLEDGMENTS

This photographic history of Arab Americans in metropolitan Detroit is the culmination of collaborative efforts of many dedicated people. Special thanks go to those individuals and families who honored their ancestors by contributing their treasured images to this publication and to organizations who responded to our request and sent photos. We are deeply indebted to the photographers whose rich images contribute so much to the telling of this story. In particular, the works of Millard Berry, Bruce Harkness, and Joan Mandell figure prominently, and to them we extend special thanks.

We also acknowledge the research and knowledge of many scholars and individuals about the Arab-American community. Their publications, which collectively comprise a lasting record of the community's history and culture, led to a general understanding of Arab Detroit.

This book also builds on many years of collaboration between the Arab Community Center for Economic and Social Services (ACCESS) and the Michigan State University Museum (MSUM) that included the traveling interpretive exhibition "A Community between Two Worlds: Arab Americans of Greater Detroit." This exhibition included photographs that comprised an earlier exhibit by Alixa Naff, Sally Howell, and Andrew Shryock, whose contributions to the exhibits made the production of this book a much easier task. A number of photographs in this publication come from these exhibitions.

Credit for this book also goes to the staff of the Michigan Traditional Arts Program of the Michigan State University Museum and the Cultural Arts Program staff of the Arab Community Center for Economic and Social Services, Janice Freij and Greta Anderson, for their dedicated, unfaltering, and capable assistance. In particular, we would like to acknowledge the contributions of Saira Mussani, who worked tirelessly on all aspects of this book.

Finally, we wish to acknowledge the generous support of the Ford Motor Company, the Arab Community Center for Economic and Social Services, and the Michigan Traditional Arts Program of Michigan State University Museum in partnership with the Michigan Council for Arts and Cultural Affairs.

INTRODUCTION

Arab Americans have been an integral part of Detroit's history since the 1880s. Arab immigrants came to Detroit looking for a better life for themselves and their families. Early Arab immigrants worked as peddlers, grocers, and unskilled laborers, settling first downtown and on the east side of Detroit. Their numbers started to increase steadily after the First World War. Like other American ethnic groups, they were attracted to the area by the booming automobile industry and Ford Motor Company's $5 for an 8-hour workday.

The vast majority of Detroit's Arab Americans came from Lebanon, Syria, Palestine, Egypt, Iraq, and Yemen. While earlier immigrants came because of Detroit's expanding economy, later Arab immigrants continued to arrive, even in times of economic recession, attracted by the security provided by kinship, the family, and fellow villagers who had already settled in the Detroit area. Today, as in the case of the latest arrivals from Yemen and Iraq, Arab immigrants are drawn to Detroit by a sense of belonging, provided by the size of the community and its established educational, religious, and cultural institutions.

More than a century of Arab immigration to metro Detroit has produced remarkably diverse communities that transcend socio-economic and religious boundaries. Arab Americans live in small towns and in major metropolitan areas. Some have settled in suburban communities, while others live in predominantly Arab-American enclaves. Some are middle and upper-class professionals, others are small business owners and factory workers. Despite their diversity, Arab Americans feel connected by a shared sense of ethnic identity and cultural heritage.

In this publication, we have tried to portray this diversity by including pictures from the various national and religious groups within the Arab-American community. We, however, could not possibly include every organization, institution, or individual's contribution. We realize the limitations of any publication of this sort to be as inclusive and even-handed as we initially intended. This book pays tribute to and acknowledges the contribution Arab Americans have made and continue to make to the Detroit area.

The steady flow of Arab immigrants has reinvigorated the ethnic identity of Arab America, as well as contributed significantly to the economy of the nation. While earlier settlers provided labor to the expanding industrial economy of Detroit, many later immigrants reversed some of the urban trends that dominated the area since the 1970s. Many of the city's older ethnic neighborhoods are dispersing at the time when both old and new Arab neighborhoods are unifying and expanding. When small retail and family businesses are disappearing from the landscape of metro Detroit, a variety of Arab immigrant businesses are flourishing. While

suburban sprawl continues to destroy inner cities and adjacent suburbs, Arab immigrants are rebuilding their old neighborhoods, as well as many parts of Detroit and its adjacent suburbs.

On January 9, 2000, The *Washington Post* travel section stated in a four-page article entitled *Not Your Father's Detroit*: "The Motor City has become the unlikely capital of Arab America. Visit its streets, lined with ethnic shops, restaurants and houses of worship, for a stateside taste of the Middle East." As Detroit celebrates its 300th anniversary, it also celebrates its vast diversity, acknowledging the contributions made by its ethnic groups, including Arab Americans. Meanwhile, Arab Americans nationwide look to Detroit as their social, cultural, and spiritual capital. Today the Arab-American community in Detroit is not only the largest and most concentrated in the country, but it is also the most organized and influential. The community is an integral part of the social and political fabric of the city.

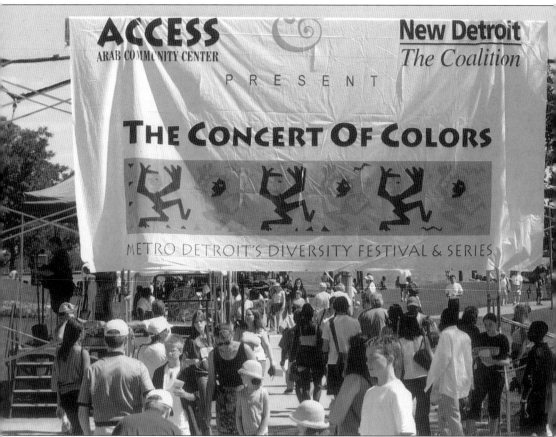

The *Concert of Colors*, sponsored by the Arab Community Center for Economic and Social Services (ACCESS) and New Detroit, Inc., was a three-day world music festival that marked the official opening of Detroit's Tricentennial celebrations.

One

IMMIGRATION

A rab immigrants started to arrive to the Detroit area in noticeable numbers in the 1880s. The earliest were mostly Christian single men from Greater Syria, known today as Syria and Lebanon. They thought of themselves as sojourners, coming to the United States to reap quick wealth and return to their villages. The inability to accumulate the anticipated wealth, coupled with the collapse of the silk industry in Lebanon and the increased taxation and conscription by the Ottoman Empire (who colonized the area until World War I), forced many to desert the idea of return. Once they saved enough money, they sent for their families and relatives, starting a chain migration by which many extended families, and even entire villages, settled in the Detroit area.

Arab immigration was a significant part of the Great Migration, the period extending from 1880 to 1924, when more than 20 million immigrants entered the United States. While most Arabs at that time came from Syria and Lebanon, a smaller number came from Palestine. A series of laws passed by U.S. Congress between 1917 and 1924 limited the immigration of non-Europeans. The booming automobile industry in Detroit, however, continued to attract many Arab immigrants from other cities in the United States.

After the Second World War, Arabs again started to arrive in large numbers. While earlier immigrants were villagers, those who arrived in the 1950s and 1960s were largely urban professionals from Syria, Lebanon, Palestine, and Egypt. During this period, the immigration of Chaldeans, a Catholic minority from Iraq, also increased.

The latest wave of Arab immigrants started in the 1970s and continues today. Changes in US immigration laws, coupled with wars, and political and economic difficulties in a number of Arab countries, persuaded many to come to the United States. The majority of Arabs who have arrived in Detroit since the 1970s are Muslims and are diverse in terms of their national, educational, and professional backgrounds. The larger number of them came from Lebanon, Iraq, and Yemen, with a smaller number from Palestine, Egypt, and Jordan. In the last few years, some immigrants from Tunisia, Morocco, and Algeria have arrived and settled in the Detroit area as well. Today, Arab Americans are drawn to Detroit from other cities by the already existing and well-established Arab-American community.

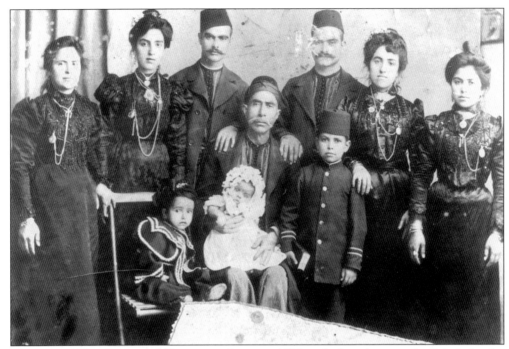

The sons of Elias Zainea left Damascus, Syria, in 1897 with this photograph of their family. Alienated from their homeland in a foreign place, this photo was a treasure, linking these young men to their loved ones back home. (Courtesy of Joe Zainea.)

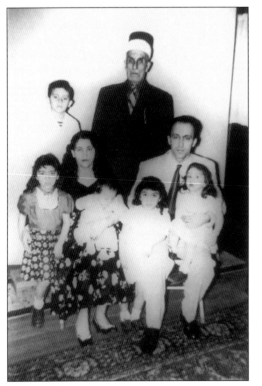

Abdullah Harp with his son, daughter-in-law, and grandchildren in 1957. Abdullah Harp was the first of three generations of Lebanese immigrants to travel to the United States in 1890. Abdullah's son Ross came in 1920, and his grandson Albert arrived, at 8 months of age, in 1950. Many immigrants at the time were single men who worked and saved money in America and then went back to their hometown to get married. Often times, their wives and families would remain in their native land until the men saved enough money to support them in the United States. They would then send for their wives and children to join them in beginning a new life. (Courtesy of Albert Harp.)

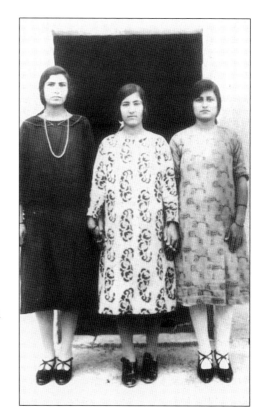

(top) Elmas Thomas poses with her cousins in Hamat, Lebanon, shortly before coming to America. Six months later, Elmas poses (bottom) with her American cousins in Louisville, Kentucky, in 1926. (Courtesy of Donna Muawwad.)

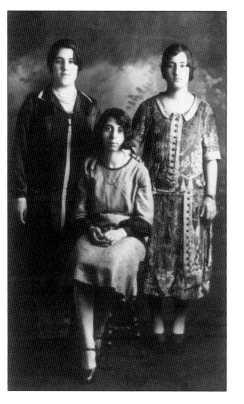

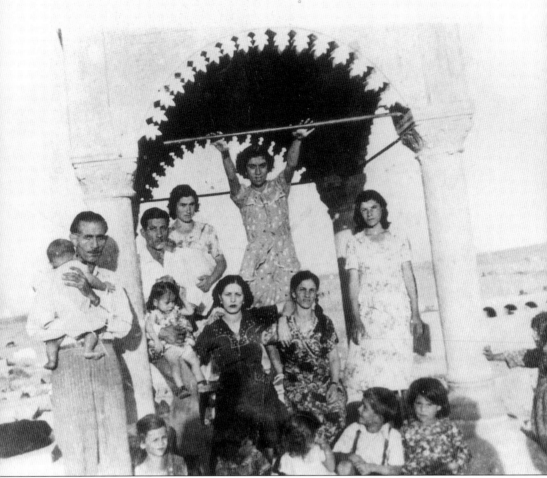

Photographed here is the Denha Family of Tell Keif, Iraq, shortly before their departure for the United States in 1949. Detroit is the home of a large Chaldean community, a Catholic minority from Iraq. In the 1960s, a larger wave of Chaldean immigrants came to the Detroit area, and continued to arrive during the 1970s and 1980s. Since the 1990 Gulf War, the number of Christian and Muslim Iraqi immigrants in the Detroit area has increased dramatically. (Courtesy of Amir Denha.)

Elias Saleh immigrated to the United States in 1895 at the age of 15 and became an American citizen in 1900. He went back to Lebanon to marry, and returned to Detroit with his wife, Leah, and their two children in 1907. They remained in Detroit until 1929 when they returned to Lebanon. (Courtesy of Noel Saleh.)

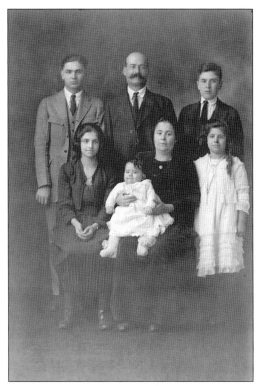

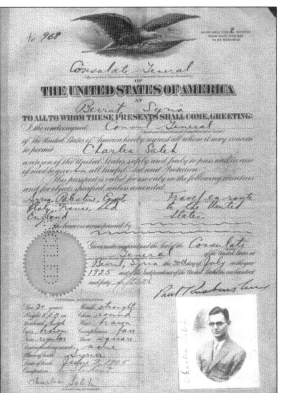

Nabih (Charles) Saleh, son of Elias Saleh, was born in Lebanon in 1905 and came to the United States with his family in 1907. Nabih returned to Lebanon in 1923. He came back to America in 1926 only to return to Lebanon once again in 1929. Nabih came back to Detroit in 1939 and got married in 1940, but went back to Lebanon in 1946 with his wife and three children. He returned a year later, finally settling in Detroit until his death in 1989. (Courtesy of Noel Saleh.)

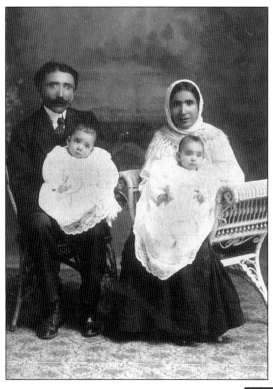

Aliya Hassen was born in Kadoka, South Dakota, in 1910. Her parents were among the first Lebanese Muslims to arrive in America. This photograph depicts Aliya (right) with her parents and brother. She moved to Detroit in 1925 to live with her cousins. (Courtesy of ACCESS.)

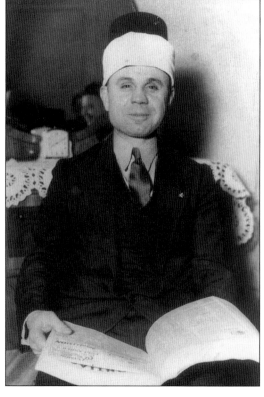

Samuel (Ismael) Shamey was born in Lebanon in 1898. He came to the United States by himself in 1920 at the age of 22, and like so many Arabs at the time, went to work at the Ford Motor Company where he was employed for 44 years. On his last day of work, which was his 65th birthday, he had a heart attack and died on the job. Since he was not "officially" retired yet, his family never received his pension. (Courtesy of Sandra Amen.)

ELLIS ISLAND
1892–1992
TM © 1987 SL/EIF, INC.

The Statue of Liberty–Ellis Island Foundation, Inc.

proudly presents this

Official Certificate of Registration

in

THE AMERICAN IMMIGRANT WALL OF HONOR

to officially certify that

SARAH ABDOUSCH ABDALLA

who came to America from

SYRIA

is among those courageous men and women who came to this country in search of personal freedom, economic opportunity and a future of hope for their families.

Lee A. Iacocca
The Statue of Liberty-Ellis Island
Foundation, Inc.

LIBERTY
1886·1986
® © 1982 SL/EIF, INC.

This is Sara Abdalla's Ellis Island official Certificate of Registration. Sara Abdalla came to the United States with her husband Dib Abdalla in 1923, via Marseille, France. Sara did not pass an eye exam and had to stay in France for a few months, where she had her first daughter, Rose. After she passed the eye exam, Sara and Rose took a ship to New York. Upon arriving at Ellis Island, Sara again did not pass the eye exam and was held at a hospital with her daughter on the Island. Her husband, who was living in Detroit at the time, was sending the hospital $4.25 a day for his wife and child. After five months he sent the hospital a letter questioning why he should pay for his daughter since she was nursing and sleeping in her mother's bed. Without responding to his inquiry, Sara and Rose were shipped back to France and Dib received a letter informing him of their departure. Mr. Abdalla went to his congressman who helped him bring his wife and daughter to Detroit. They spent an additional 13 months at the hospital. By the time Sara joined her husband, she had crossed the Atlantic Ocean three times. (Courtesy of Marie Abdalla.)

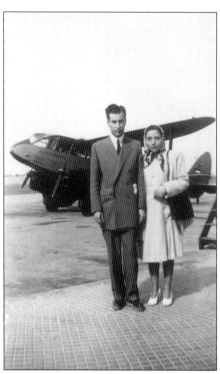

Amer and Sana Kadaj bid farewell to Palestine in 1947. They had originally planned to stay in America only a few months, but war in Palestine and new opportunities in America convinced them to become American citizens. (Courtesy of Lila Kadaj.)

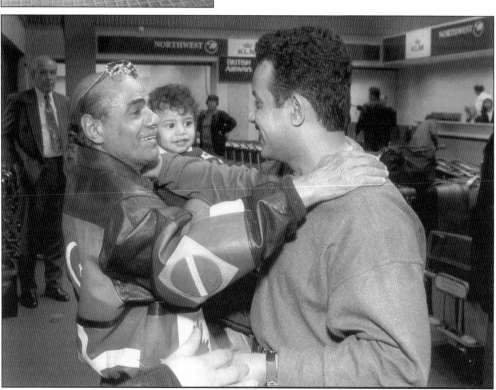

At Detroit Metro Airport in 1995, the Kulaib family greets a son who waited eight years for his immigration papers to be processed. (Photo by Millard Berry.)

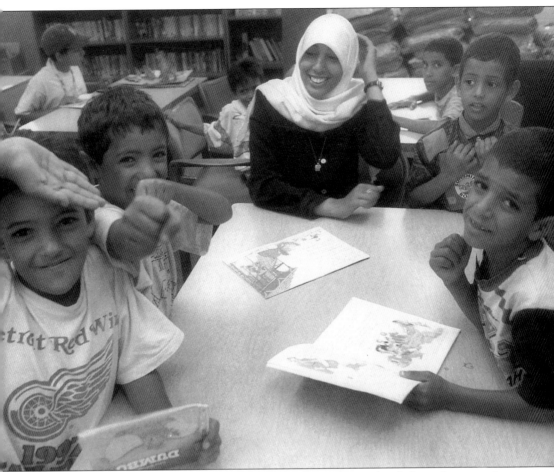

The children of newly arrived immigrants are shown here taking a break from their tutoring session at the Aliya Hassen Library of the Arab American Community Center for Economic and Social Services (ACCESS) in 1999. Since its inception, ACCESS has helped new immigrants from the Arab World adjust to life in America. ACCESS provides a wide range of services including employment, health, social services, and education. (Photo by Millard Berry.)

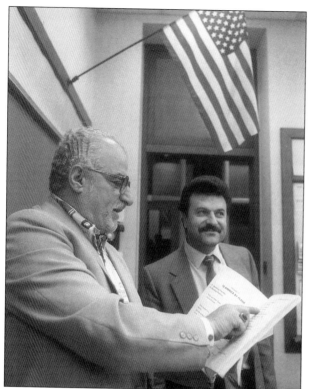

Wagih Saad, principal of Salina Elementary School in Dearborn's South End, oversees an American citizenship class in 1987. (Photo by Millard Berry.)

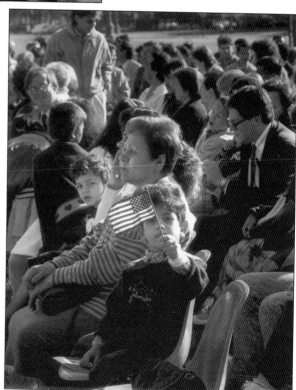

New citizens are sworn in at Dearborn's Henry Ford Museum and Greenfield Village in 1990. (Photo by Millard Berry.)

Two

FAMILY

For Arab Americans, family is the most important social and economic institution. Early Arab immigrants, mostly single men, came to the United States in order to support and maintain their families whom they temporarily left behind. They worked hard and walked miles after miles peddling in order to save and send money to family members in the "old country." Once financially secure, they started patterns of chain migration, bringing parents, brothers and sisters, brides, uncles, aunts, and cousins, until the whole extended family was reunited in their new home, Detroit.

Earlier immigrants helped newcomers start their lives. They provided a support system, which helped new immigrants adjust and acclimate to a culture very different from their own. They helped them find employment and provided a place to live until the newly arrived could stand on their own. Also, they introduced them to the area's social and religious institutions established by earlier immigrants in order to preserve Arab identity and culture.

The Arab-American extended family continues to thrive. Relatives live together in the same neighborhood, and sometimes in the same household. They often work and socialize together, making it easier to preserve the culture and traditions that are so important to them. This emphasis on extended family is learned by each successive generation and reinforced by new immigrants. As second and third generation Arab Americans begin adapting to mainstream American culture and start to adopt the nuclear family lifestyle, newer immigrants arrive with strong family ties binding generations together and keeping the extended Arab family structure alive. This structure has helped hundreds and thousands of Arab immigrants adjust, succeed, and thrive in their new homes in and around Detroit, and in many cities throughout the United States.

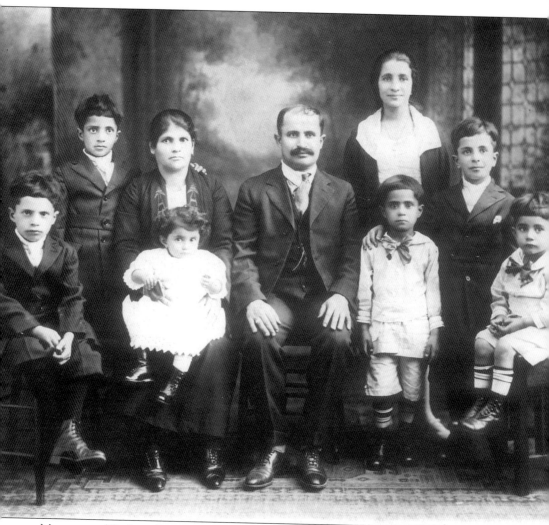

Mansour and Barbara (Zaina) Abdoo pose with their children for a family picture in the 1920s. The couple came to Detroit from Lebanon in 1905, one year after they were married. They settled in the downtown area along with many other Maronite immigrants. Mansour initially worked as a peddler and then bought his own grocery store. He lived in Detroit until his death in 1961. (Courtesy of Greg Abdoo.)

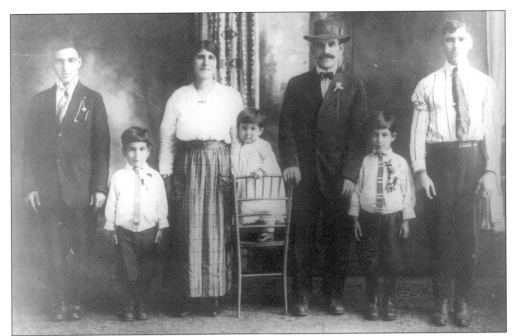

Benjamin and Sarah Dib, their three sons Michael, James, and Albert, and Benjamin's two nephews, Dib Abdalla and Jessie Dib Albert are shown here in 1920. Benjamin and his wife, Sarah, came from a small village in Syria to Detroit in 1908, at the ages of 30 and 23. Their children were born in Detroit. (Courtesy of Ollie and Marie Abdall.)

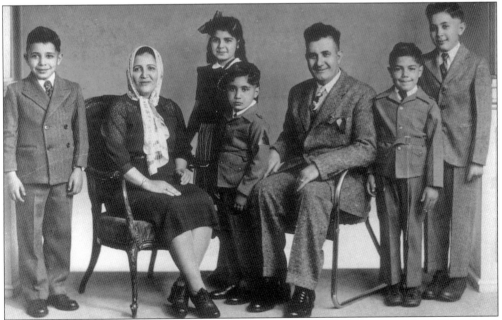

This is the Hassan Turfe Family, who were immigrants from Lebanon, in the 1930s. Posed photographs of this kind were commonly taken to send to the family in the old country. With everyone dressed in their best, the family shows that everyone is doing well and that life in the new world is good. (Courtesy of Andrea Amen.)

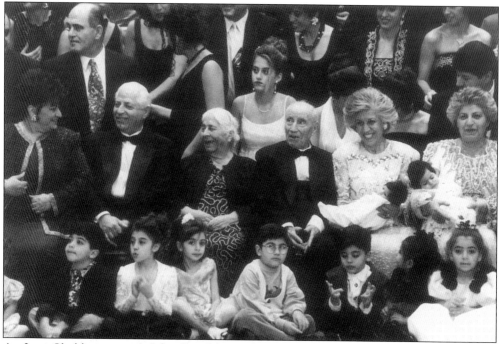

An Iraqi Chaldean extended family celebrate the Yono's 75th wedding anniversary, in 1995. (Courtesy of *Detroit News*, Jack Gruber.)

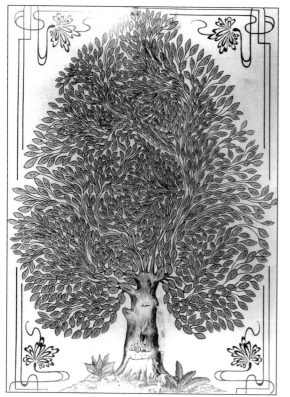

The prevailing symbol of kinship is the family tree. In Arabic this tree is called *shajarat nasab*, and it details the male bloodline on the father's side, linking kin to a single male ancestor. Recorded in the same tradition as that of Jesus and the Prophet Muhammad, Yusif Barakat's ancestry is inscribed on the leaves of this olive tree. When Yusif came to the United States in 1948, he brought with him this family tree, made by a professional genealogist in Palestine in the 1930s. (Courtesy of Yusif Barakat.)

After a nine-year engagement, Dib and Sara Abdalla were married in 1922. Dib joined his uncle in Detroit in 1912. At that time it was common for young men to come by themselves, find work, and send money to their families. Once financially stable, they would send for their families. When single men had saved enough, they often went back and married a girl from their hometown. Dib Abdalla worked for ten years, sending money to his parents and his fiancée's family before returning to his village in Syria to marry Sara. (Courtesy of Marie and Ollie Abdalla.)

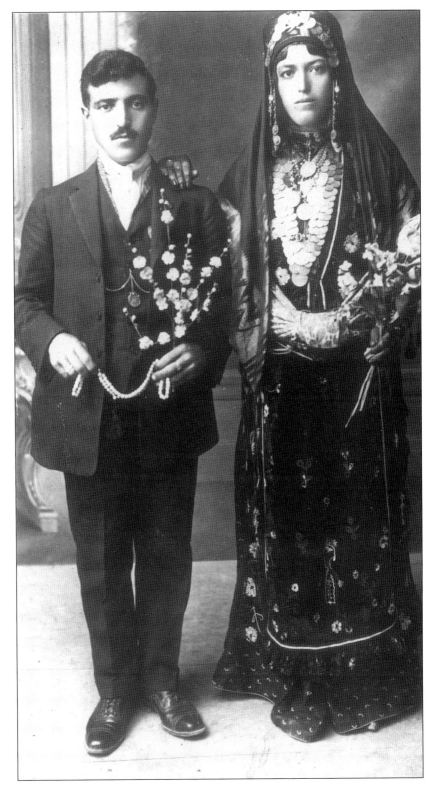

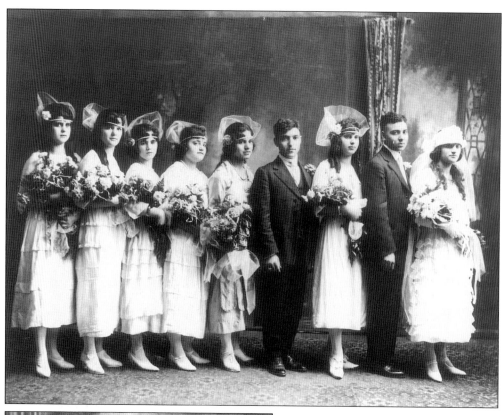

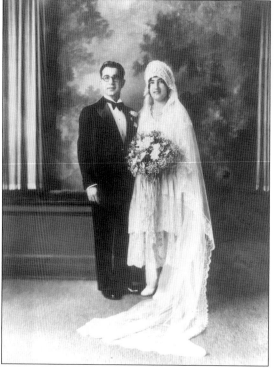

Mary Atia and Diab Barakat, seen here with their bridesmaids, pose at a photographer's studio for a wedding picture in the early 1920s. All the women are Syrian. The second man standing in the middle is the bride's father. (Courtesy of Marie and Ollie Abdalla.)

This is a wedding portrait of Elmas Thomas and Saleem Metry. They were married in Detroit in 1929. (Courtesy of Donna Muawwad.)

The wedding of George Zainea and Theresa Jacobs took place in 1956 at the Lady of Redemption Melkite Church on McDougall and Charlevoix, on Detroit's east side. Early Syrian Americans belonged to the Melkite Church, an Eastern Rite Catholic Church.

This is to Certify that

Mr. *Saleem J. Metry*

of *Detroit*

State of *Michigan* and

Miss *Elmas Thomas*

of *Louisville*

State of *Kentucky*

were by me united in

Holy Matrimony

According to the Ordinance of God and the laws of the State of *Kentucky* at *Louisville* on the 5" day of *March* AD *1929*.

[Arabic text]

In presence of

anthony Gabriel

(Witnesses)

Eliza J. Gabriel Rev. geo. Michael

Nelson Cullbroon
EDI

What therefore God hath joined together
let no man put asunder St. Mathew 19:6

Minister

To the right is the wedding certificate for Elmas Thomas and Saleem Metry. (Courtesy of Donna Muawwad.)

25

Bishara Freij and his wife, Helen, are seen here in 1973. Bishara came to Detroit with his family in 1968, one year after his hometown, Ramallah, was occupied by Israel. Many Palestinians came to the United States at that period. Bishara went back to Ramallah in 1973, where he met Helen Ishaq. They married in Ramallah and moved to Detroit later that same year.

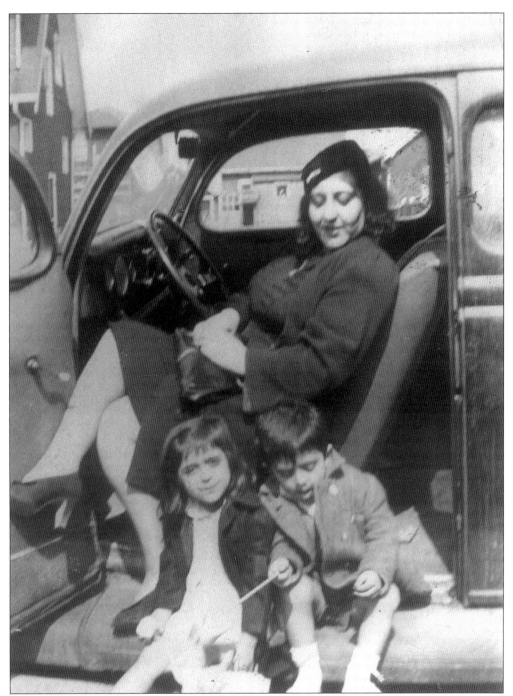

Mary (Zainab) Shamey, with her daughter and son, is seen on Robertson Street in Dearborn in 1942. Prior to Mary's birth in Mexico, her parents and uncle took a train from Mexico to the United States. The train was attacked by bandits, who robbed and killed Mary's father and uncle. Her mother, who was pregnant at the time, went back to Mexico. She came to Detroit in 1913, after giving birth to her daughter Mary. Mary lived in Detroit until her death in 1997. (Courtesy of Sandra Amen.)

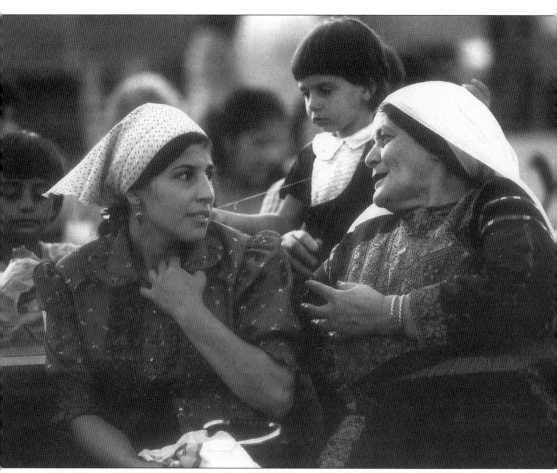

Three generations of Palestinian-American women chat at a picnic in 1983. Picnics are popular summer social events during which friends and families gather to share food, visit, listen to Arabic music, and dance. Many of the Palestinian Americans who lived in the South End neighborhood in Dearborn have moved to the suburbs or to other cities. (Photo by Millard Berry.)

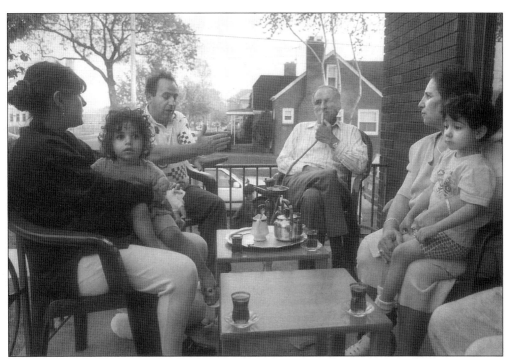

Sweet tea, a water pipe, and news of the day; a Dearborn family unwinds in the late afternoon. The porch is an important locus of family life in Dearborn. Here they visit with neighbors and passers-by, in 1995. (Photo by Millard Berry.)

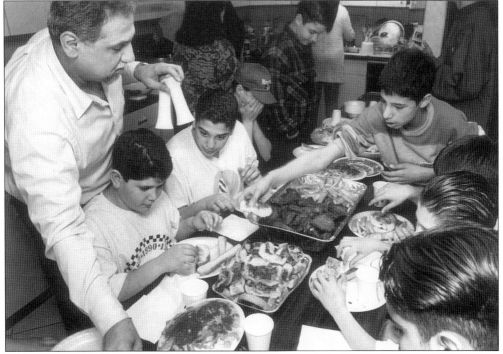

The Amen Family celebrates their son Bilal's birthday in 1995. (Photo by Bruce Harkness.)

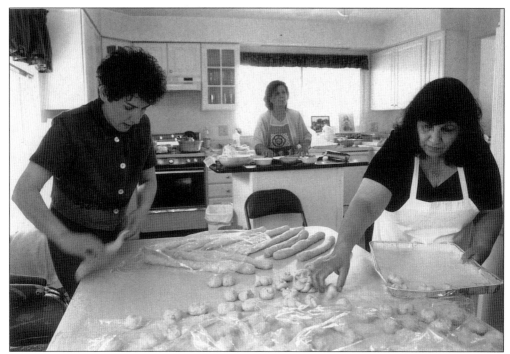

Friends Julia Najor, Victoria Elias, and Ahlam Nafsou (left to right) make *lefat al-kameera* from 15 pounds of flour at Julia's West Bloomfield home. They typically take turns at each other's homes to prepare pastries for guests. This image is from 2001. (Photo by Joan Mandell.)

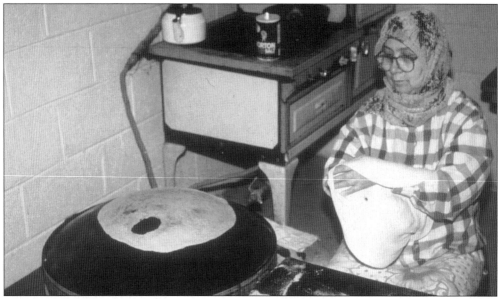

Bread is the basis of the Arab diet. Fatme Boomrad, who came to Dearborn in the 1950s from southern Lebanon, makes *khobz*—thin bread baked on a *sajj* in this 1998 photograph. Despite its availability in local bakeries, she regularly makes her own because it tastes best fresh. This bread so symbolizes Arab culture and cuisine that some restaurants now employ immigrant women to make it in full view of their patrons. (Photo by William G. Lockwood.)

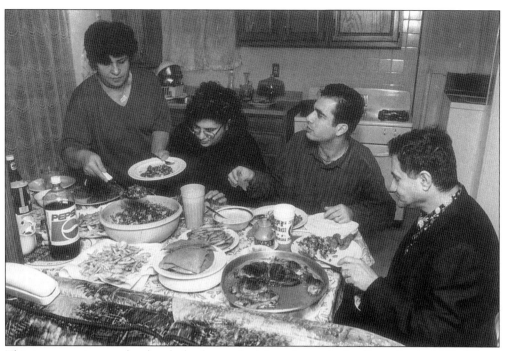

This is an evening meal to break the fast at the Mroue home during Ramadan in 1995. (Photo by Bruce Harkness.)

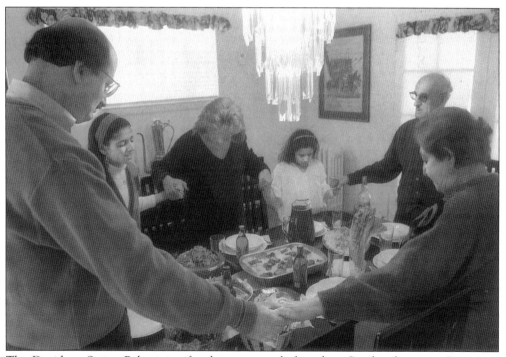

The Davids, a Syrian-Palestinian family, say grace before their Sunday dinner in Detroit in 1995. It is customary for families to come together on the weekend, usually for Sunday dinner. (Photo by Millard Berry.)

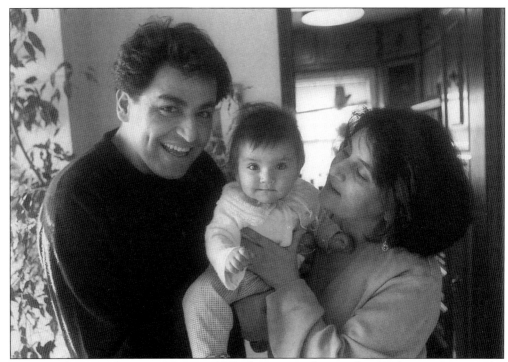

Mujan Seif-Azzo and parents, Nader and Wejdan are seen here in this 1995 image. Many of the younger Arab American professional couples are having smaller families of one or two children. (Photo by Millard Berry.)

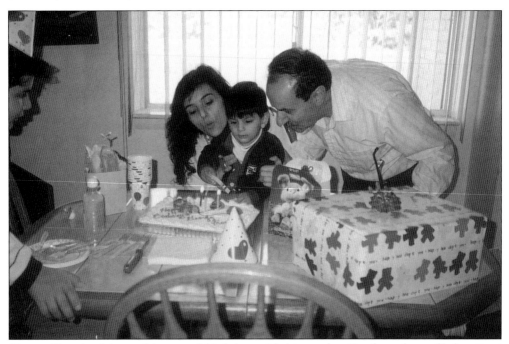

George Kaoud celebrates his second birthday, with his mother Sandy and grandfather Faraj Freij, in 1994. (Courtesy of Janice Freij.)

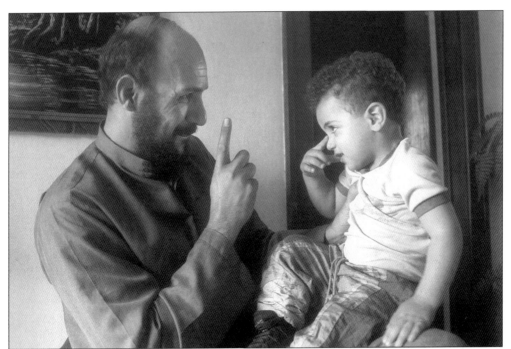

A newly arrived Iraqi Shi'a refugee plays finger games with his nephew in 1994. Since the 1990 Gulf War, a large number of Iraqis have been arriving in Detroit. Today the number of Iraqi refugees in the Detroit area is estimated at 15,000, and they represent the largest number of new immigrants in the last few years. (Photo by Millard Berry.)

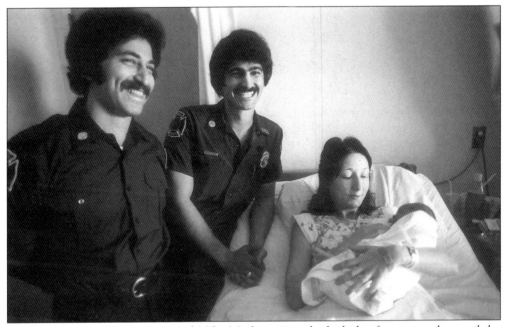

Dearborn firemen, Dave Amen and Mike Moslimani, at the bedside of a new mother, and the baby they helped deliver in 1978. The baby was named David Michael in honor of them. (Photo by Millard Berry.)

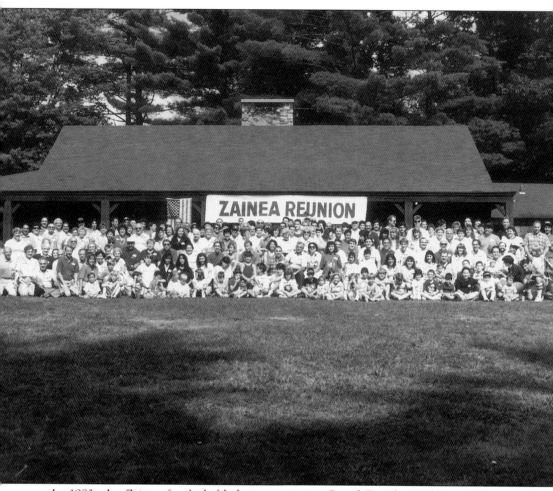

In 1993, the Zainea family held their reunion in Grand Rapids, Michigan. These are the offspring of six brothers and one sister. The first brother, Joe, came to the United States in 1898. As a result of chain migration, four brothers, a sister, and a sister-in-law followed between 1900 and 1907. The brothers settled in Grand Rapids and worked in a furniture store. One of the brothers came to Detroit and became a very successful businessman. He owned a creamery on Detroit's east side, and a business complex that consisted of a restaurant, theatre, and bowling alley on Woodward Avenue, in the Detroit cultural district. (Courtesy of George Zainea.)

Three
RELIGION

The main religions of the Arab-American population are Christianity and Islam. Today, it is estimated that half of the Arab Americans in metro Detroit are Muslims, and half are Christians.

Arab-American Christians take pride in being the first followers of Jesus Christ. While sharing many of the same beliefs and principles of other Christians, Arab Christians came to the United States with their own denominations of Christianity, like the Egyptian Coptic Church. Most non-Catholic Arab Christians belong to Eastern Rite Churches, which include Antiochan, Assyrian, and Syrian Orthodox. Catholic Arabs belong to churches, which include the Maronite, Melkite, and Syrian Catholic. Iraqi Chaldeans are also Catholic.

There are two main branches of Islam: Sunni and Shi'a. Both branches uphold the same principles of Islam, though there are some differences in practice and custom. The Detroit area is home to the largest Arab-American Muslim population in the United States.

Early Arab immigrants did not establish their own places of worship immediately after arriving in Detroit. Christians attended churches in their neighborhoods. It was, however, much more difficult for Muslim immigrants to practice their religion collectively until they built their own mosque in Highland Park in 1923. Friday prayer was often held at the homes of their religious leaders, relatives, or friends.

Once the community was established, Arab Americans built their own churches and mosques. These religious institutions became central to the social, political, and religious life of their communities. Among the earliest churches in Detroit are the St. Maron Maronite Church founded in 1897, St. George Orthodox Church built in 1916, and the Melkite Church built in 1929. The first mosque was built in Highland Park in 1923. As the members of these religious institutions increased and moved to the suburbs, newer and larger ones were built. Today metropolitan Detroit is the home of more than 40 Arab-American mosques and churches.

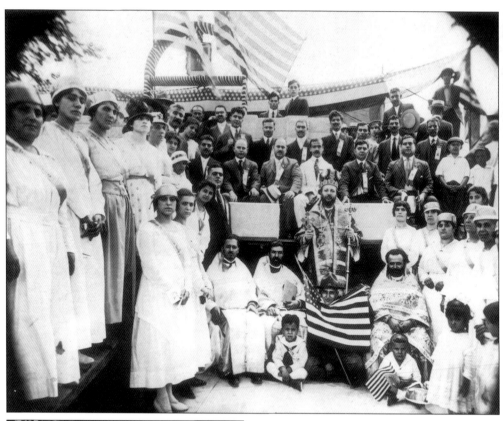

This is the 1918 dedication of St. George's Orthodox Church of Detroit. (Courtesy of Warren David.)

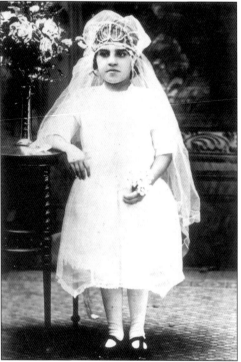

Kathleen Eva Hatty, a Maronite Catholic, is seen here on the day of her first communion in the mid-1920s. (Courtesy of Jim Stokes.)

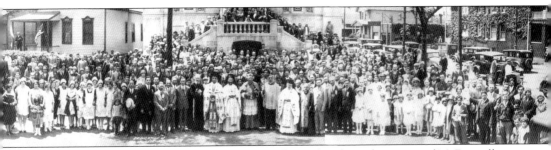

This is the dedication of the Lady of Redemption Melkite Church, at the corner of McDougall and Charlevoix on Detroit's east side, in 1926. As the community moved out of Detroit, the church relocated to Warren, Michigan, in 1983. (Courtesy of Lady of Redemption Melkite Church.)

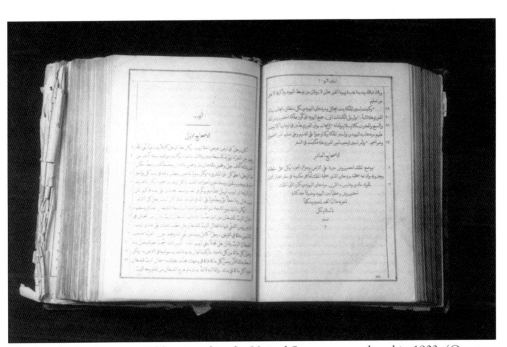

The first Arabic-language Bible printed in the United States was produced in 1903. (Courtesy of Alfred Khoury, Photo by Joan Mandell.)

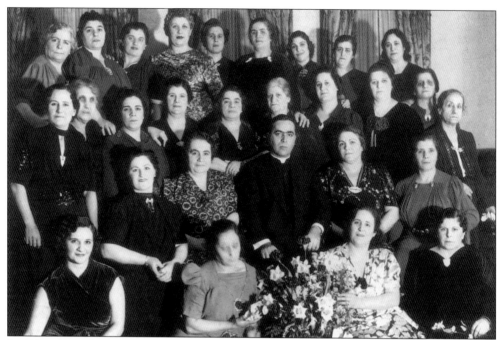

In 1937, the Ladies' Society of the Lady of Redemption Church gave an automobile as a gift to Pastor Elias Cuter. Arab women, both Muslims and Christians, are the backbone of their social and religious institutions. (Courtesy of George Zainea.)

This is the Founding Women's Club of the American Bekaa Moslem Society in 1938. At the time, Muslims were a minority among Arab Americans. Many of them settled in Highland Park, an independent city encircled by Detroit, to work at the Ford Plant. Later they moved to Dearborn's South End to work in Ford's new River Rouge Plant, where they built a new mosque.

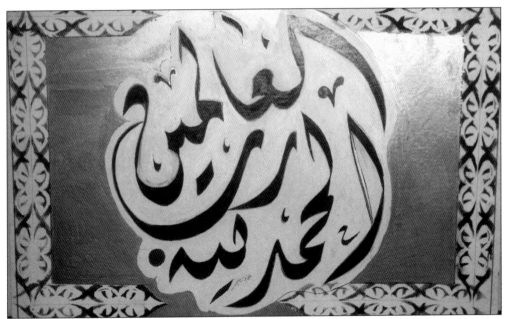

This Arabic calligraphy by Aziz Mohammed al Shabi reads "Thanks to God, the Lord of the Universe." Calligraphy is a two-dimensional representation in Islamic art and one of the most venerated art forms laden with meaning. It dates back to the earliest days of Islam, where as a stylized handwriting its initial purpose was to copy religious texts. Later it was used to write all kinds of documents and to decorate buildings and objects. Today, some calligraphers have moved from using pen and paper to computer-generated scripts, which are subsequently applied to objects or cut out of vinyl.

These verses from the Book of Psalms, 37:23–25, were written in Syriac script by the famous Chaldean calligrapher Deacon Paulus Kasha, in the village of Al-Kosh, Iraq, in 1962. (Courtesy of Athir Shayota.)

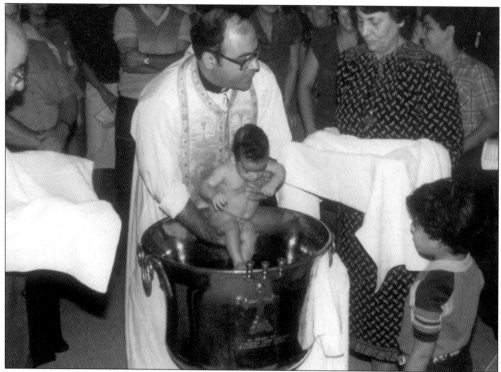

George Freij is baptized by Father Shalhoub in 1982 at St. Mary's Orthodox Church in Livonia, a suburb of Detroit with a large concentration of Palestinian Americans from the West Bank city of Ramallah. (Courtesy of Janice Freij.)

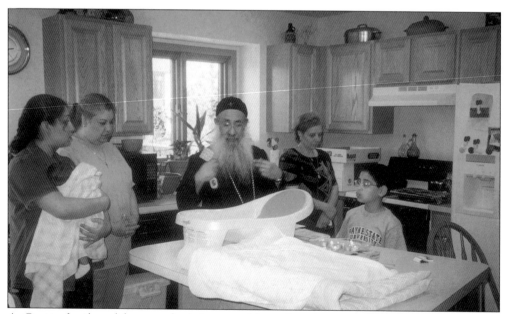

A Coptic family celebrates *suboa'* (one week) at their home with their priest. Egyptian-American Christians belong to the Coptic Church. It is an Egyptian tradition, observed by Muslims and Christians, to celebrate *suboa'* after a child's birth.

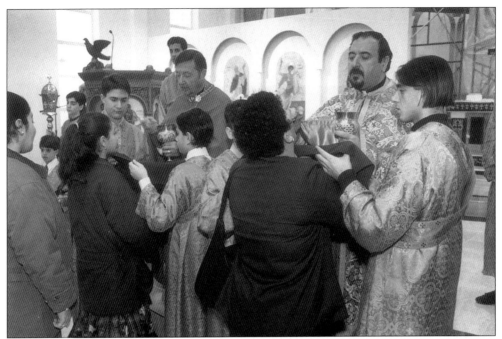

Priests of St. George's Antiochan Orthodox Church, in Troy, with the assistance of acolytes, serve communion to the congregation in 1995. (Photo by Bruce Harkness.)

Members of Sacred Heart Chaldean Church would immediately recognize this prayer book, written in Syriac script. Syriac is an ancient Semitic language closely related to Aramaic, the language spoken by Christ. (Courtesy of Father Jacob Yasso.)

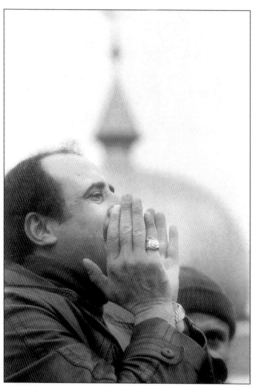

In this 1980 photograph in Dearborn, a *muezzin* (Muslim crier) calls the faithful to prayer. Devout Muslims pray five times a day. (Photo by Millard Berry.)

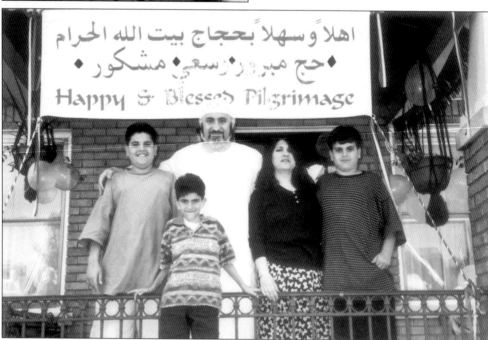

اهلاً وسهلاً بحجاج بيت الله الحرام
• حج مبرور وسعي مشكور •
Happy & Blessed Pilgrimage

Albert Harp, just back from his first pilgrimage to Mecca (*hajj*), is welcomed home by his family in 1995. The *hajj* is a sacred obligation. Unless financially or physically unable, observant Muslims make the *hajj* at least once in their life. The banner hanging from the porch celebrates Harp's successful completion of the *hajj*. (Courtesy of Albert Harp.)

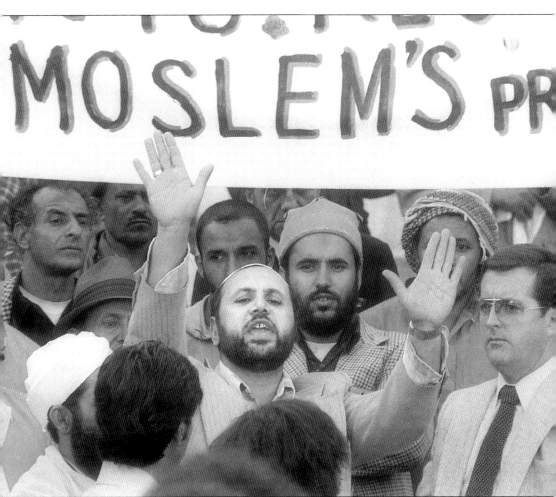

In 1980, Muslims rallied for the right to broadcast the call to prayer, while residents near the mosque complained about the noise. The court decided in favor of the broadcast. Historically, the faithful worshiped in their neighborhood mosque and the *muezzin* called people to prayer from the minaret with nothing more than a megaphone. Today the call is usually an amplified recording. (Courtesy of Millard Berry.)

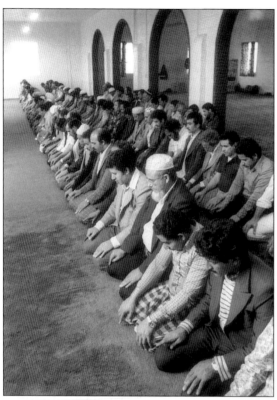

In this photograph, Muslims are at prayer. Facing toward the holy city of Mecca, an observant Muslim prays five times a day, a requirement of Islam, which one can do at home, work, or in the mosque. Friday being the Islamic holy day, Muslims participate in communal prayer at the mosque. Men and women pray in separate sections of the mosque.

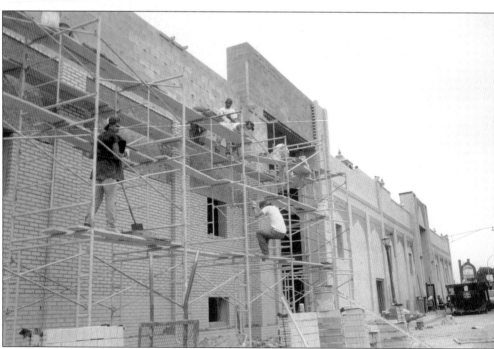

As the community continues to grow, the Dix Street Mosque underwent an expansion in 2001. (Photo by Joan Mandell.)

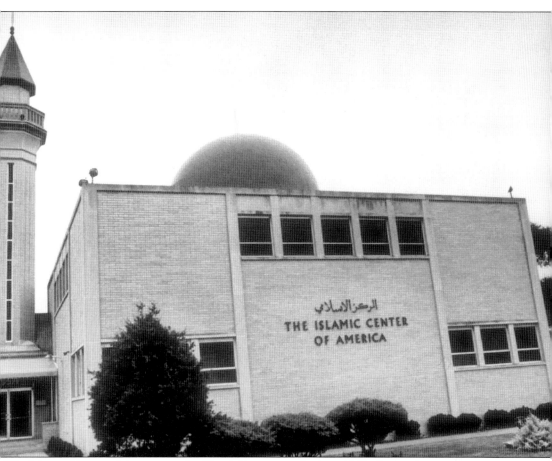

The Islamic Center of America on Joy Road, Detroit was built in 1963. Currently a new mosque is being built to accommodate the increasing number of Arab-American Shi'a Muslims in metropolitan Detroit. Shi'a Muslims broke from the Sunni community in the first decades of Islam over the succession to the Caliphate, the spiritual and political leadership of Muslims. However, the day-to-day practice of faith differs very little between them. This photograph was taken in 2001. (Photo by Joan Mandell.)

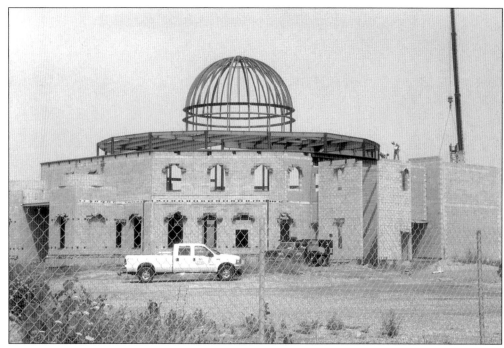

The Islamic Center of America builds a new mosque on Ford Road in west Dearborn in 2001. A sign in front announces, "Expanding to serve our community." (Photo by Joan Mandell.)

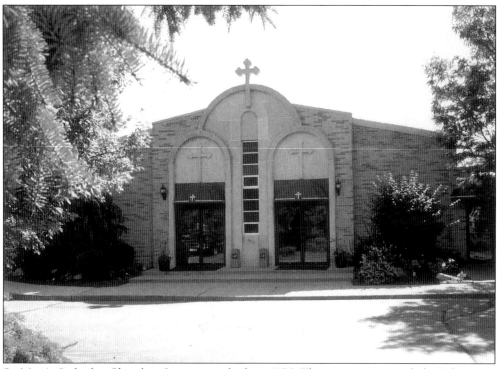

St. Mary's Orthodox Church in Livonia was built in 1976. The congregation includes Palestinian Americans from the West Bank city of Ramallah, 2001. (Photo by Joan Mandell.)

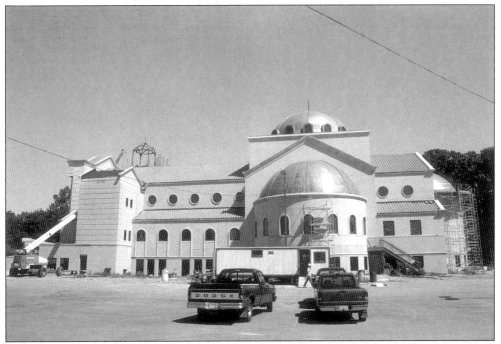

A new St. Mary's Orthodox Church is being constructed next door to the older building in 2001. (Photo by Joan Mandell.)

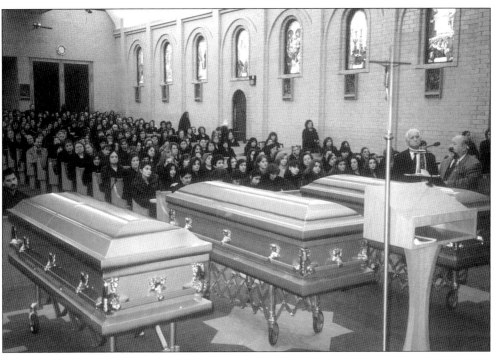

Funeral services were held at the Mother of God Chaldean Rite Catholic Church in Southfield, Michigan, for three family members who died in a house fire. (Courtesy of the Mother of God Church.)

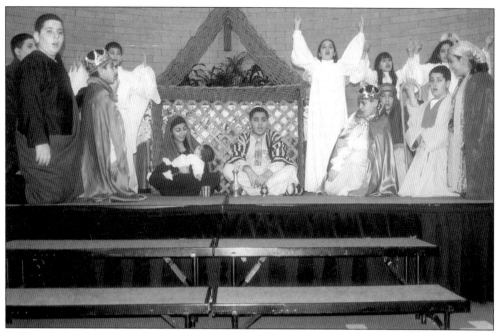

Each year the children of the Mother of God Chaldean Rite Church in Southfield, Michigan, perform a Christmas play about the birth of Jesus Christ. (Courtesy of the Mother of God Church.)

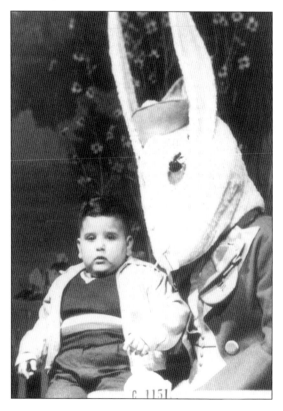

Jim Stokes, a Syrian-Lebanese American, meets the Easter Bunny in 1955. (Courtesy of Jim Stokes.)

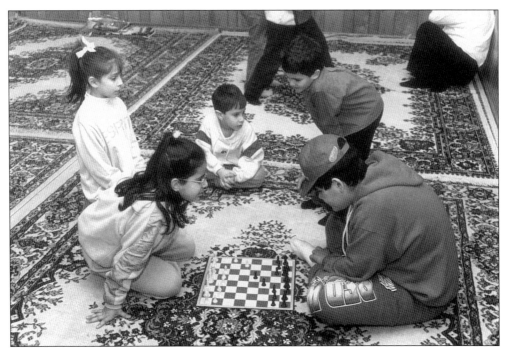

In addition to their religious and spiritual roles, churches and mosques also function as important social and educational centers. Children play at the American Bekaa Moslem Center in 1995. (Photo by Bruce Harkness.)

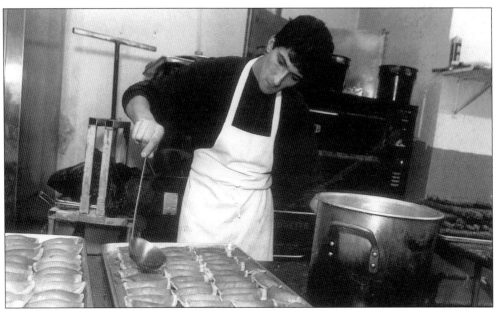

During the holy month of Ramadan, observant Muslims fast from sunrise to sunset. When they break the fast each evening, their meal has been prepared with careful attention. Although the foods are not necessarily different from any other time, there are some that are special for Ramadan. This baker at the Masri Sweet Shop in Dearborn is making a Ramadan specialty, *katayef*, a crepe filled with nuts or cheese.

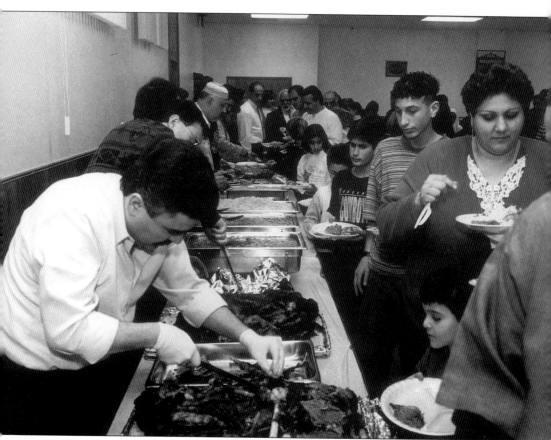

Breaking the fast during Ramadan is often a communal act, as seen here at the Lebanese Social Club in 1995. Usually people break fast with their extended family, neighbors, and friends. During the month of Ramadan, the social clubs often coordinate the feasts so that different clubs host the meal.

Four

WORK

When Arab immigrants came to Detroit in the late 1880s, they had limited skills and little formal education. They were equipped, however, with a strong will to work, and determination to succeed. Since that time, successive waves of Arab immigrants have arrived, and many changes have occurred in the Arab-American community. Today Arab Americans and their children are an important part of metro Detroit's work force and an integral part of the its social, cultural, political, and economic landscape.

Many early Arab immigrants worked as unskilled laborers while others took to the road as peddlers, selling goods from house to house. Peddlers saved to support their families in their countries of origin, and were later able to save enough to open businesses of their own. These businesses became the center of family life, as many families lived above stores or in back rooms. These businesses often employed new immigrants, who in turn worked hard until they, too, were able to open their own stores.

Not all Arab immigrants peddled wares and started up their own businesses. Many were employed as laborers, helping to build Detroit's industrial economy. They were attracted by the booming automobile industry; some of the Yemeni immigrants also went to work on ships in the Great Lakes. Today it is hard to separate the history of Arab Americans from that of Detroit's labor and automobile industry. Arab communities emerged next to automotive plants. The Arab community of Highland Park moved to Dearborn in the 1920s to work at Ford Motor Company's Rouge Plant. Today the most concentrated and distinct Arab-American communities are in Dearborn, home of Ford Motor Company and its Rouge Plant. It is important to note that Iraqi Chaldean immigrants, who started to arrive in Detroit in large numbers in the 1960s, primarily specialized in the food industry. Today, most of Detroit's family food stores are owned by Chaldean Americans.

Many children of earlier immigrants have been able to pursue careers different from their parents. Thanks to hard work and advanced education, many became doctors, lawyers, engineers, teachers, and other professionals. New arrivals fill the vacancy left by earlier immigrants in the auto industry and family businesses. While some recent immigrants are following the same general path as earlier arrivals, many come with more education and

financial resources than their predecessors and are able to establish themselves at a much more accelerated pace.

Today's Arab businesses are spread throughout metro Detroit and include grocery and convenience stores, gas stations, restaurants, hotels, beauty salons, engineering firms, and pharmacies. Arab Americans are involved in every type of occupation, from manual and unskilled labor, to highly professional careers.

The history of Arab-American work is extensive and varied. Despite the different trends and developments, the spirit of entrepreneurship and the automobile industry tend to define the Arab experience, and shape their presence in metro Detroit.

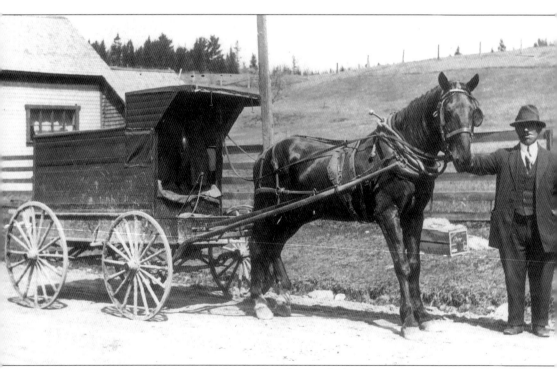

Syrian immigrant Abraham Swide peddles dry goods by horse and rig, c. 1915. Peddling merchandise was one of the common occupations of immigrants. Merchants carried cases on their backs or drove horse-drawn wagons (and later, automobiles), traveling door to door, offering a wide variety of merchandise (such as crocheted doilies often made by the women of their family, oriental rugs, tapestries, towels, watches, sewing equipment, etc.) to urban and rural families. Many aspired to establish their own stores. Even with a store, some continued to peddle while a family member managed it. (Courtesy of Jim Stokes.)

Dib Abdalla, back from serving in World War I in 1919, poses proudly in uniform in front of the American flag. He was among hundreds of Arab immigrants who enlisted during the war. Those who were not yet naturalized citizens were awarded citizenship for serving their new country. (Courtesy of the Abdalla family.)

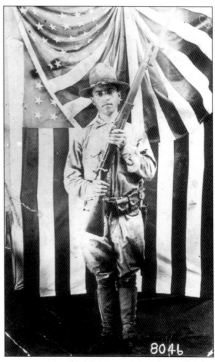

The Ajami brothers proudly stand in front of their new grocery store in downtown Detroit in 1916. Entrepreneurship was, and still is, very strong among Arab Americans, and many families established grocery stores and other food producing businesses. As the establishment grew, it provided employment for relatives brought to the United States. (Courtesy of the Naff Arab-American Collection.)

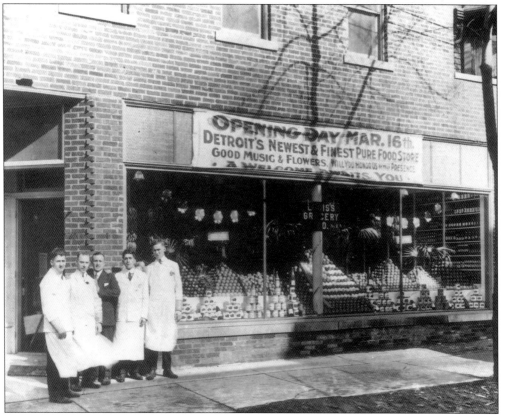

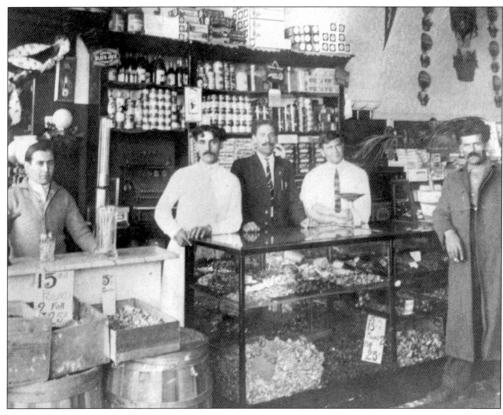

This is one of the early grocery stores in downtown Detroit. In the first decades of the 20th century, merchants sold American products—imported Arabic spices and foods were not yet readily available in Detroit.

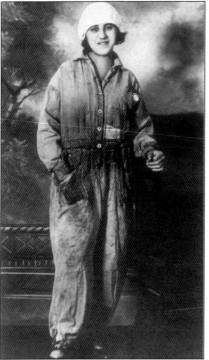

Eva Hatty, a Lebanese autoworker, poses in her coveralls in 1929. She was one of the few Arab females of her generation to work in a factory. At the time, most women worked from home or at the family grocery store. (Courtesy of Warren David.)

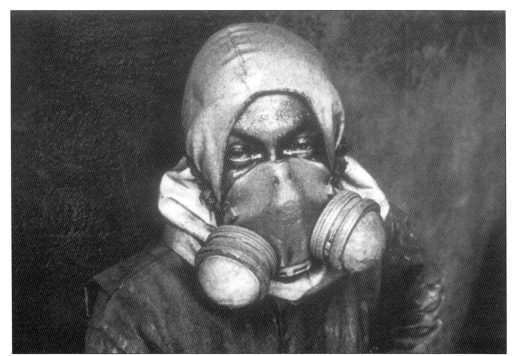

Mislimani, an Arab immigrant in his work gear at the Ford Rouge Plant, worked at Ford Motor Company for 35 years. In the first decades of the 20th century, many Arab immigrants came to Detroit to work in automobile factories when conditions were very difficult and unsafe. Many Arabs still work in the automobile industry.

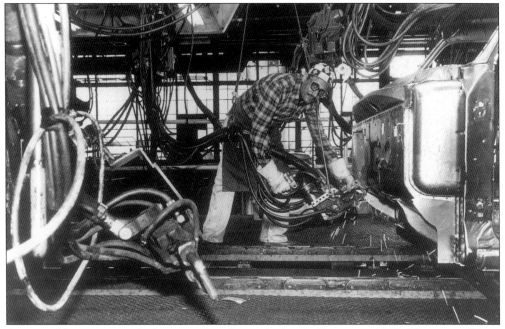

A spot welder is seen on the line at a Chrysler truck plant in Detroit in 1980. (Courtesy of Tony Maine.)

Ali Baleed Almaklani, known to his coworkers as "Mike," makes windshields at the Ford Rouge Plant, 1993. (Photo by Joan Mandell.)

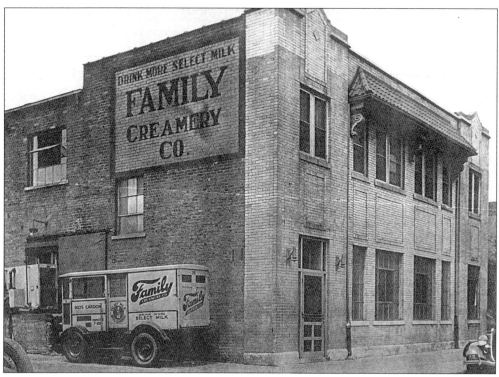

Drink More, Select Milk: the Lutfy, Zainea, Jacob, Cuter, and Simon families from Damascus, Syria, founded A Family Creamery in 1919. By the 1930s it was the largest creamery in Detroit. It was sold in 1960.

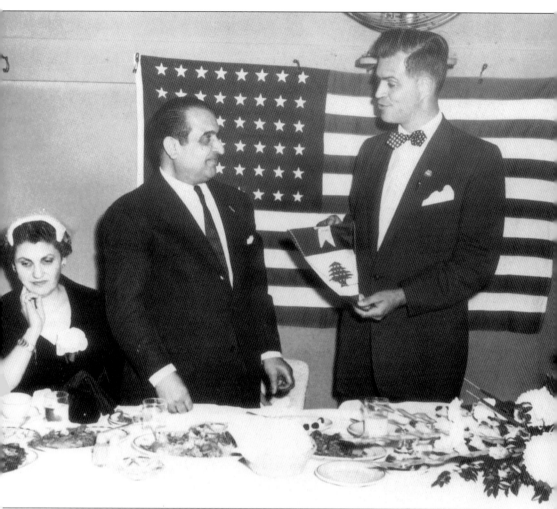

In 1956, Governor G. Mennen Williams honored Fadel Ganem, proprietor of the Sheik Restaurant, with the "Outstanding Immigrant of the Year" award. According to family legend, the award recognized him for "having introduced Arab food to the public in Detroit." (Courtesy of Lila Ganem-Fuher.)

The Sheik Restaurant and proprietor Fadel Ganem are seen here, c. 1950. The Sheik was the first Arab restaurant in Michigan. It was established before the Great Depression in downtown Detroit in what was then the Maronite community. The Sheik served familiar, inexpensive meals to the large number of single Arab men and the occasional non-Arab. The restaurant closed during the Depression, reopening across the street in a larger building in 1944. When Fadel died, his oldest daughter's husband managed it until his death. His widow and her sister ran the restaurant until it closed in 1987. For many older Detroiters, the Sheik was where their concept of Arab food was created. (Courtesy of Lila Ganem-Fuher.)

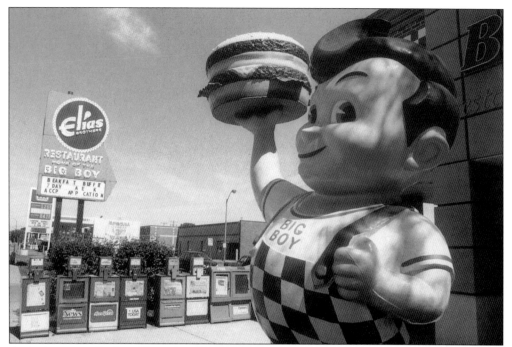

Arab-American Zachour Yousef established Elias Brothers' Big Boy restaurants. (Photo by Joan Mandell.)

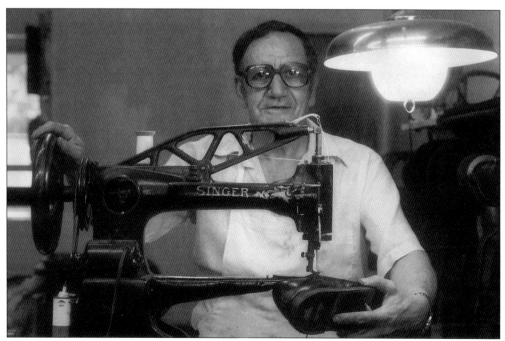

Mohammed Saad is a cobbler in Dearborn. In certain areas of the city, Arab markets and service industries exist to the exclusion of any other, and one need not know English to do business. Everything and anything is available. This image is from 1982. (Courtesy of Millard Berry.)

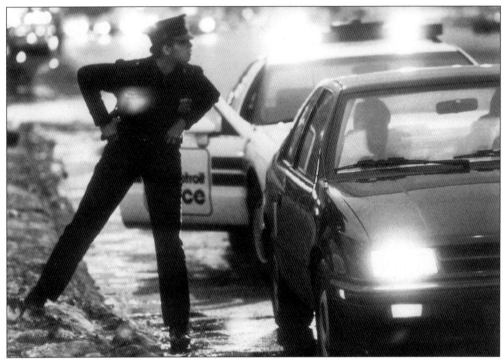

Wedad El-Hage, a Lebanese-born woman and Detroit police officer, questions a motorist in 1994. (Courtesy of *Detroit News*, Dale G. Young.)

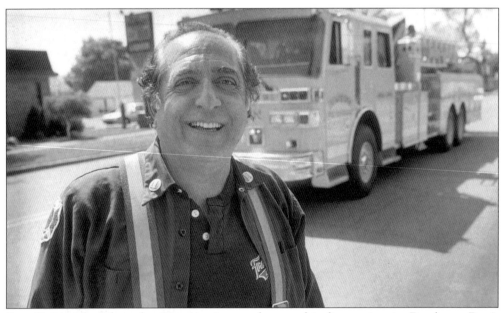

Don Unis, a firefighter for 32 years, is seen here at his fire station in Dearborn. Don's grandfather was one of the very early Arab immigrants, arriving in the Detroit area in 1886. When Ford opened the River Rouge Plant in Dearborn, the Unis family, like so many families of autoworkers, left Highland Park to settle in Dearborn. Don's father served in World War I; later Don served in the United States Army.

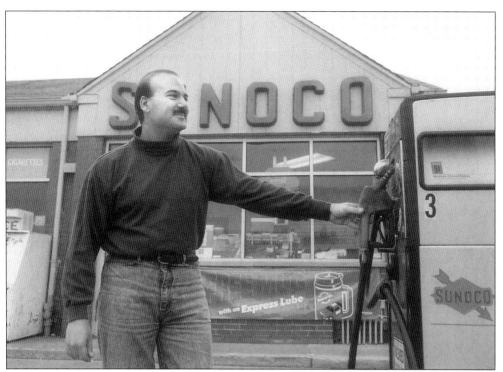

Sahid Mansour works at his gas station on Ford Road, Dearborn, in 1995. A large number of gas stations in metropolitan Detroit are owned by Arabs. (Courtesy of Millard Berry.)

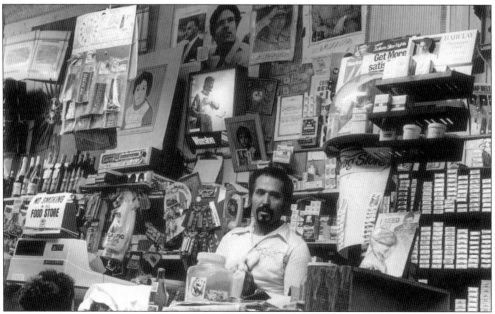

A Yemeni shopkeeper is seen in Hamtramck, an independent town surrounded by Detroit, in 1983. Hamtramck and the South End of Dearborn are the two larger Yemeni residential and business areas. This general store offers food and a variety of general merchandise, and provides an environment for Yemeni men to socialize with one another. (Courtesy of Tony Maine.)

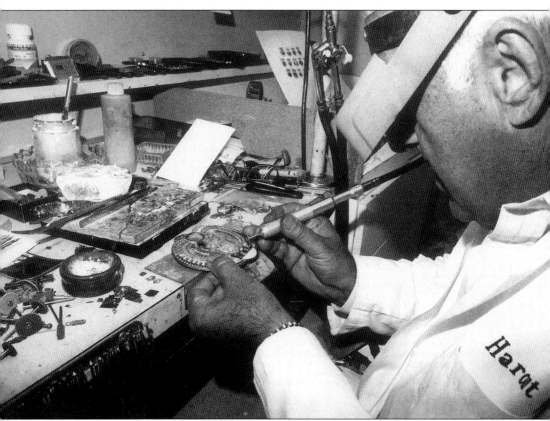

Harout Eurdekian, an Armenian goldsmith from Beirut, Lebanon, arrived in Detroit in 1969 with only $55 in his pocket. He spoke five languages, however, and possessed the outstanding skills and knowledge of a master goldsmith. By 1972 he had his own workshop and salesroom. Harout's customers include the Arab-American community, with this photograph being from the early 1990s. (Photo by Haajar Mitchell.)

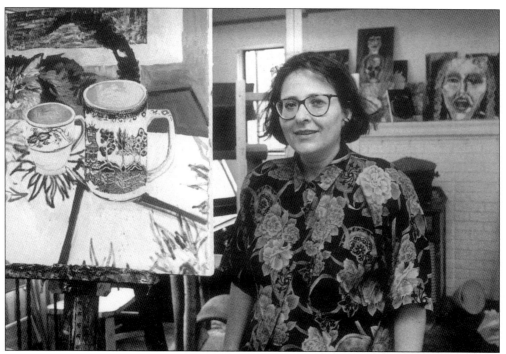

Lila Kadaj is a well-known local artist and art teacher. She is among the pioneering Arab-American women to choose art as a career. Both her parents were accomplished musicians. As the community becomes financially more secure, more Arab-American men and women are choosing the arts as a career.

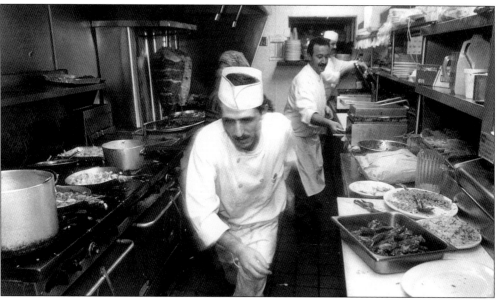

This photo, taken in 1995, depicts the dinner rush hour at the popular Lebanese restaurant Al-Ameer in Dearborn. There are some one hundred restaurants in the greater Detroit area that serve Arab cuisine. The majority of them offer cuisine of the Levant; however, one can also find Chaldean, Yemeni, and Iraqi restaurants. (Courtesy of Bruce Harkness.)

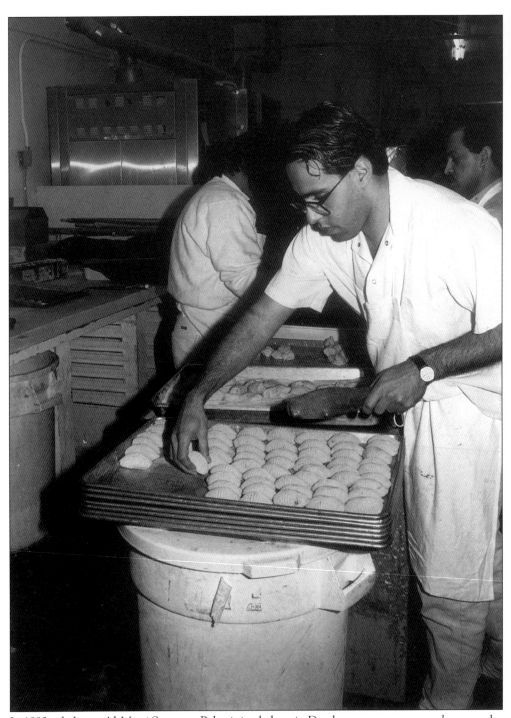

In 1993, a baker at Al-Masri Sweets, a Palestinian bakery in Dearborn, prepares *mamoul*—a popular molded cookie filled with ground nuts or dates. Since the 1970s, with a larger influx of Arab immigrants, restaurants, bakeries, halal butchers, and grocery stores line the streets of Dearborn. Al-Masri Sweets is one of the few non-Lebanese bakeries offering Palestinian specialties, as well as other popular Arab pastries and French-style cakes. (Photo by Haajar Mitchell.)

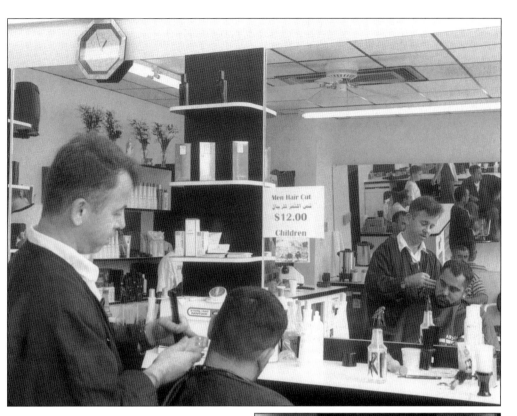

Amir Khusmi cuts hair at Babylonian Hair Design in the Chaldean business and residential area on Seven Mile Road, Detroit in 2001. (Photo by Joan Mandell.)

This is a 1993 ribbon-cutting ceremony at Dearborn's Arab Community Center for Economical and Social Services (ACCESS) Day Care facility, a welcome innovation for many working Arab American mothers. (Courtesy of Millard Berry.)

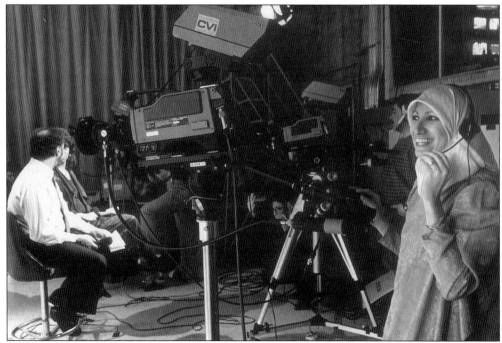

Lila Amen works off camera as a volunteer at the annual telethon for Dearborn's ACCESS in 1995. (Courtesy of Millard Berry.)

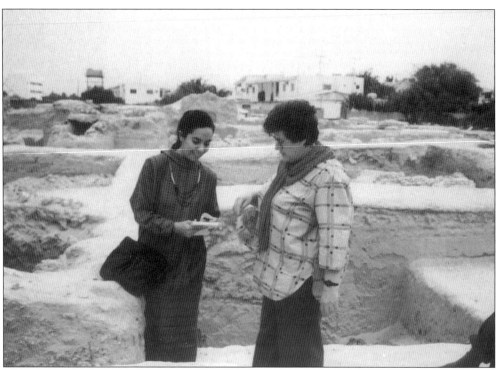

Dr. May Seikaly, professor of history at Wayne State University, pursues her research at an archeological site in Bahrain in 1994.

Natasha Ghoneim applies her skills as a television reporter to serve as Mistress of Ceremonies at the 2001 annual banquet of the Arab Community Center for Economic and Social Services. (Photo by Atef Al-Sayed.)

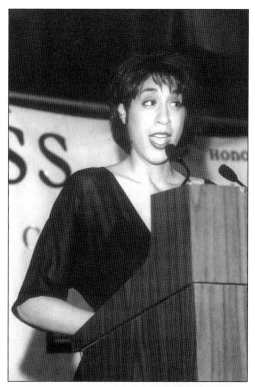

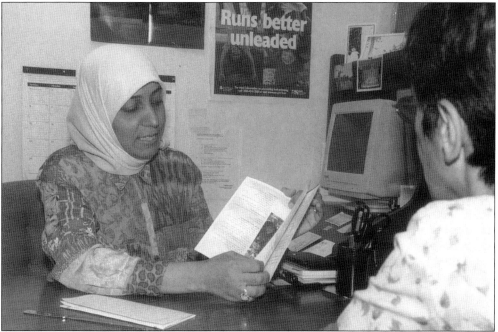

Dr. Karima Bouchiba, an Algerian-American public health professional, is among the increasing number of professional Arab women immigrating to the United States. Although a small number compared with other national groups from the Arab world, Algerians are making their home in Detroit. This photo was taken in 2001. (Photo by Joan Mandell.)

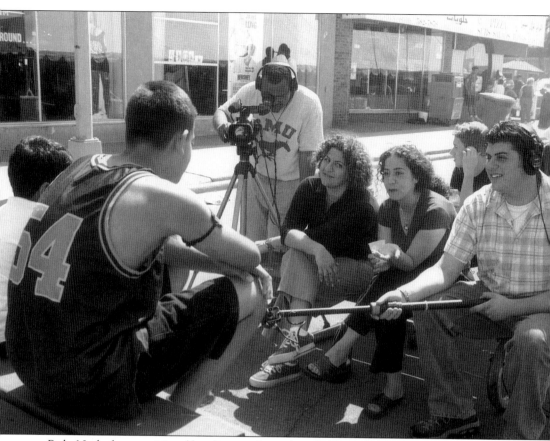

Rola Nashef, an aspiring film director (seated on left), and a group of Arab Americans are making a 2001 documentary film *My Cousin's Wedding*. (Photo by Joan Mandell.)

Five
COMMUNITY PROFILE

The United States is the home of an estimated 5 million people who trace their roots to one of the 21 countries in the Arab World. Twelve of these countries are in Asia and nine are in Africa. Arab Americans are one of the fastest growing ethnic groups in the Detroit area. It is estimated that in the year 2000 there were approximately 300,000 Arab Americans living in southeast Michigan, many of them in the Metro Detroit area.

Arab Americans are found in almost every suburb and community of metro Detroit, from the wealthiest areas of Grosse Pointe, Birmingham, and Bloomfield Hills, to the working class neighborhoods of Dearborn's South End, Hamtramck, and southwest Detroit. The diversity of the community goes beyond socio-economic status, it is also reflected in the time of immigration, level of acculturation, and religious and national backgrounds. Many third and fourth-generation Arab Americans are completely acculturated, while some more recent immigrants know very little English and are still trying to adjust to a culture very different from their own.

As more Arab immigrants arrive in metro Detroit, their ethnically distinct communities have become permanent features of the area. The largest and most predominant Arab-American communities reside in Dearborn's South End and Warren District, and the Seven-Mile area of Detroit.

Dearborn's South End, in the shadow of Ford's Rouge plant, is the oldest Arab neighborhood. Arab Americans have been moving there since the 1920s. In the late 1960s, Arab residents, mostly autoworkers, led the fight against the city of Dearborn Urban Renewal plans and managed to save part of the neighborhood from demolition. Today 90 percent of the South End population is Arab American. The area attracts a large number of new immigrants, most recently from Iraq and Yemen.

Another notable Arab community is in east Dearborn, where immigrants from Lebanon have been settling since the 1970s. Since the 1990 Gulf War, a large number of Iraqi refugees have been settling there too. Today, the business district on Warren Avenue is lined with bakeries, restaurants, grocery stores, beauty shops, coffee shops, and religious and cultural institutions that attract Arab Americans from other cities, including neighboring states and Canada.

Among other distinct communities in the City is the predominantly Chaldean neighborhood, situated in the Seven-Mile area, where a large number of newly arrived immigrants from Iraq have been settling. As earlier immigrants become established, they move to the suburbs making room for newer immigrants. The business district includes a variety of stores and services identified by Chaldean and Arabic signs. Smaller neighborhoods include parts of Southfield and Hamtramck, where a number of Iraqi and Yemeni communities and businesses are found.

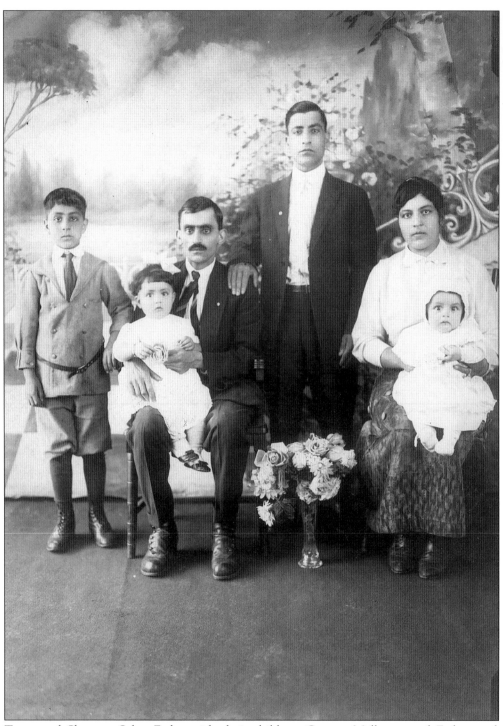

Tonas and Shumsee Sebra Zedan with their children, George, Mallaney, and Zedan, and Shumsee's brother Tonas Sebra are seen here in 1917. Tonas Zedan came to the United States from Syria in 1905 via Ellis Island. He went first to Cincinnati, Ohio, and later to Detroit. He worked most of his life at the Ford Motor Company. (Courtesy of Josephine Zedan.)

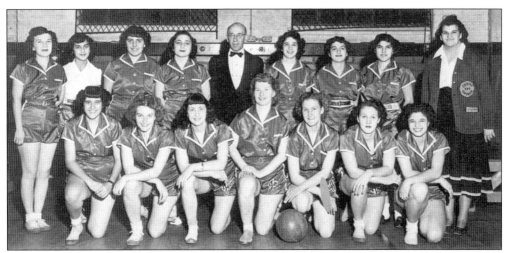

The Syrian-American Women's Basketball Team of the Christ Church, Detroit, is seen here with the Reverend Sperry. The team was established in 1949. (Courtesy of Josephine Zedan.)

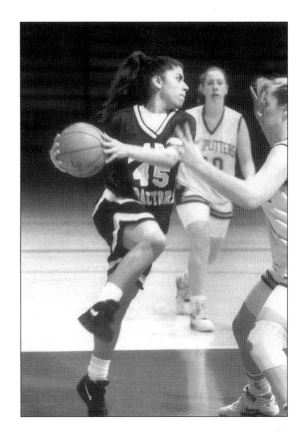

Linda Jumaa of the basketball team, Lady Tractors, was photographed in Dearborn in 1992. (Photo by Millard Berry.)

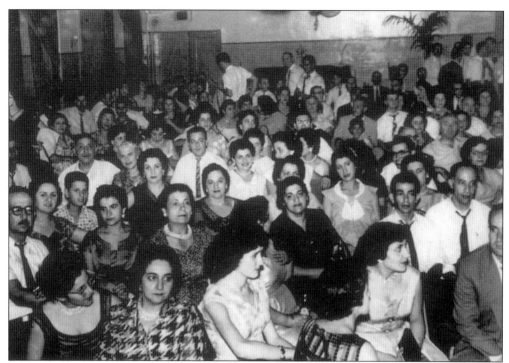

The banquet (*hefleh*) of the first convention of the Ramallah Federation of Palestine was held in Detroit in 1959. Greater Detroit is the home of a large Palestinian-American community, the majority of whom are from Ramallah in the West Bank. (Courtesy of Karim Ajluni.)

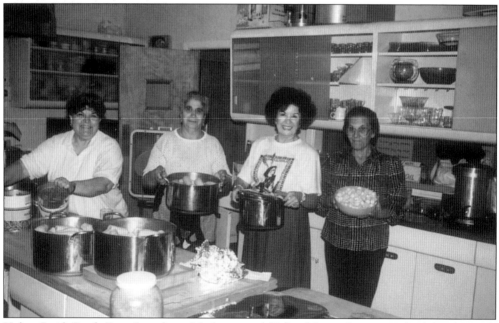

Helen Staif, Sarah Esse, Josephine Mashour, and Helen Howarah prepare food for the 75th anniversary celebration of the Christ Church of Detroit in 1990. (Courtesy of Josephine Zedan.)

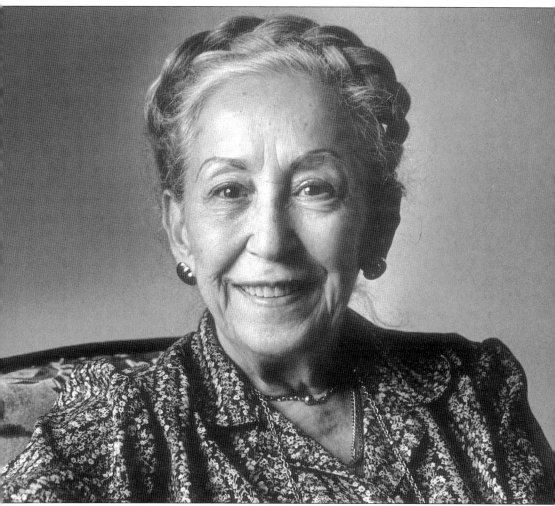

Aliya Hassen was one of Arab America's most effective leaders. Born in South Dakota in 1910 to Lebanese-Muslim immigrants, she was a strong and tireless advocate for Arab Americans and Islam until her death in 1990. Aliya Hassen was a guiding force in the development of the Arab Community Center for Economic and Social Services (ACCESS). Under her direction, ACCESS provided language classes, food, housing, and translation services to new immigrants. Her legacy continues in the work of ACCESS and the growth of the Arab community. (Photo by Millard Berry.)

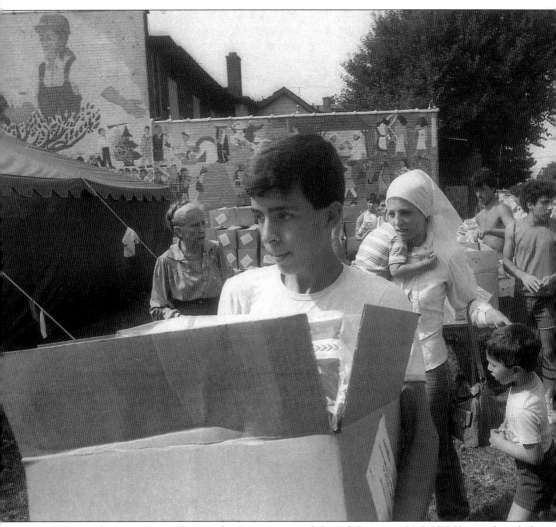

The Arab Community Center for Economic and Social Services (ACCESS) was founded in 1972 to serve the increasing number of Arab immigrants arriving in Detroit. In 1978 a fire destroyed the entire building, but devoted individuals continued to fulfill the mission of ACCESS, serving the community out of a tent. Today, ACCESS has five buildings and an annual budget of $10 million. (Photo by Millard Berry.)

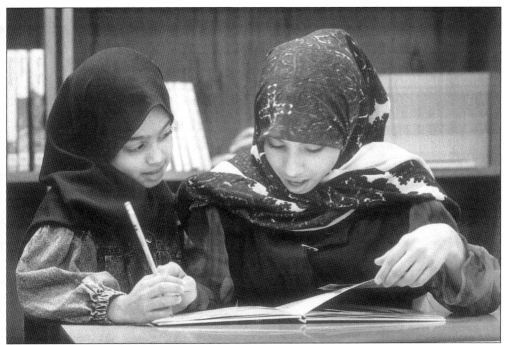
Two young Yemeni girls learn to read. Immigration from Yemen and Iraq increased dramatically since the 1990 Gulf War and continues today.

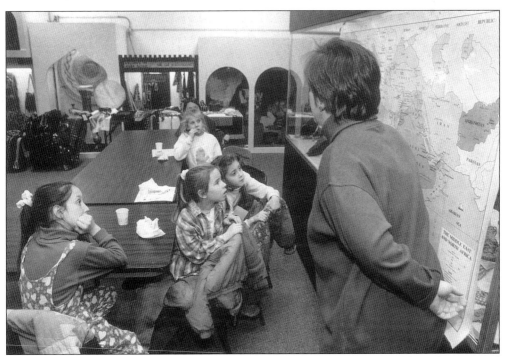
As the Arab-American community grows in size and stature, school children from around metropolitan Detroit come to ACCESS to learn more about the Arab World and Arab Americans.

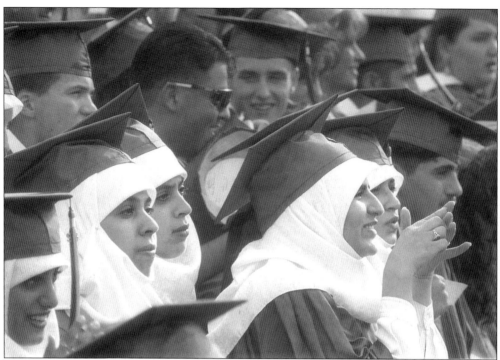

This is a high school graduation at Fordson High, Dearborn, in 1994. (Photo by Millard Berry.)

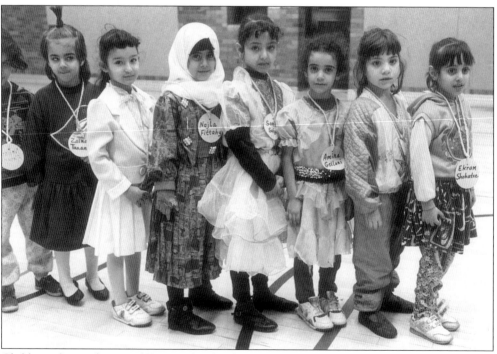

Children of recently arrived Yemeni families line up to get their gifts from Santa Claus at Salina School in the South End of Dearborn in 1994. (Photo by Bruce Harkness.)

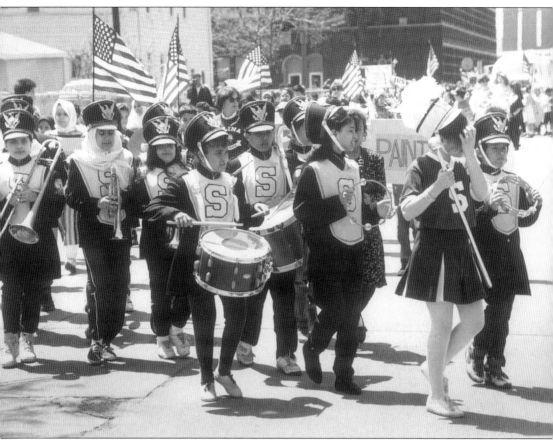

The Salina Elementary School Marching Band prepares to parade in Dearborn in 1994. Over 95 percent of the students are Arab American, which reflects the population of the South End of Dearborn itself. (Photo by Bruce Harkness.)

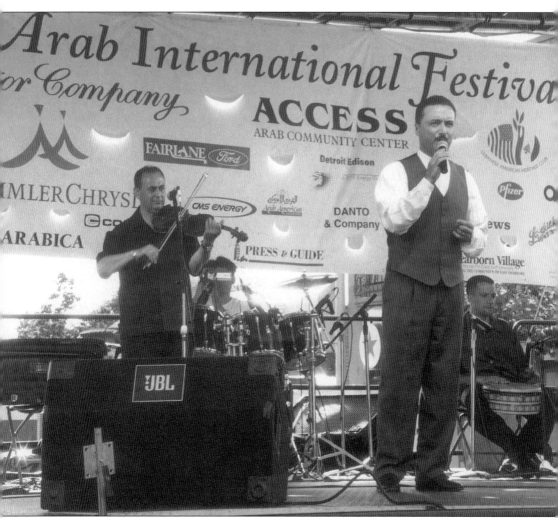

Vocalist Ali Barada, along with Hisham Mishmish on the violin, perform at the 2001 Arab International Festival in east Dearborn. ACCESS initiated this festival of Arab-American art and culture in the mid-1990s to lure Detroiters into the Arab business section of east Dearborn and to teach more about Arab Americans. Today, this successful event is coordinated by the American Arab Chamber of Commerce in conjunction with ACCESS. (Photo by Joan Mandell.)

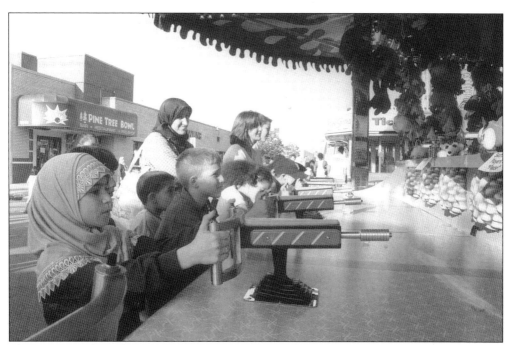

This is an arcade on Warren Avenue during the Arab International Festival in Dearborn in 2001. (Photo by Joan Mandell.)

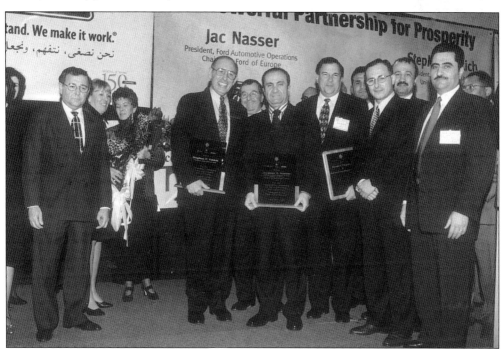

In 1998, the American Arab Chamber of Commerce honored two Arab Americans and top leaders of the automobile industry, who traditionally have been on opposite sides of the bargaining table: Steve Yokich, President of the International United Auto Workers, and Jacques Nassar, Chief Executive Officer of the Ford Motor Company. (Photo by Bilal Mokdad.)

The Employment and Human Services Center of ACCESS in Dearborn opened in 1999. The mural depicting scenes from the history of the Arab World by Ali Ramahi encircles the first floor lobby. (Photo by Joan Mandell.)

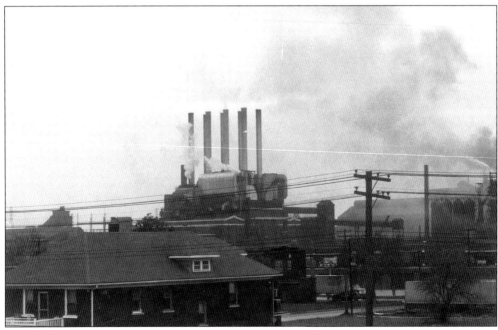

In this 1979 photograph, the Ford River Rouge Plant dominates the landscape as it looms over the South End of Dearborn. Arabs moved to this neighborhood so they could walk to work. While the close proximity of the plant is convenient for workers, it also pollutes their neighborhood. (Courtesy of ACCESS.)

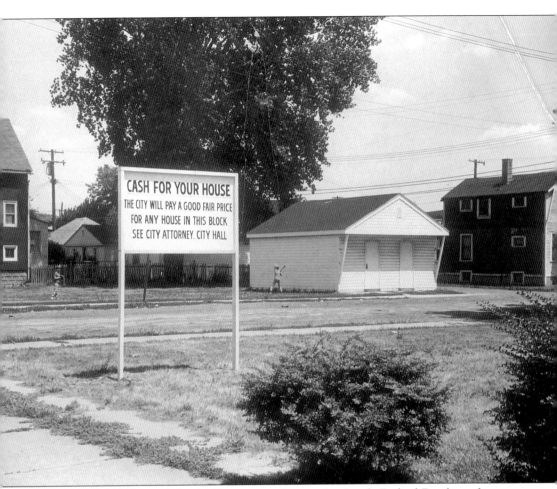

The urban renewal plans of the 1960s were to change the South End of Dearborn from a residential to industrial zone. Autoworkers employed at the nearby River Rouge Plant and their families managed to stop complete demolition, preserving parts of the area as residential. Many families, however, have since moved from this highly polluted, working-class neighborhood, making room for more recent immigrants mostly from Yemen and Iraq. Today the population of Dearborn's South End—with its bakeries, groceries, men's coffee shops, restaurants, mosque, community organizations including ACCESS, and many newly constructed homes—is predominantly Arab American. This image is from 1971. (Courtesy of ACCESS.)

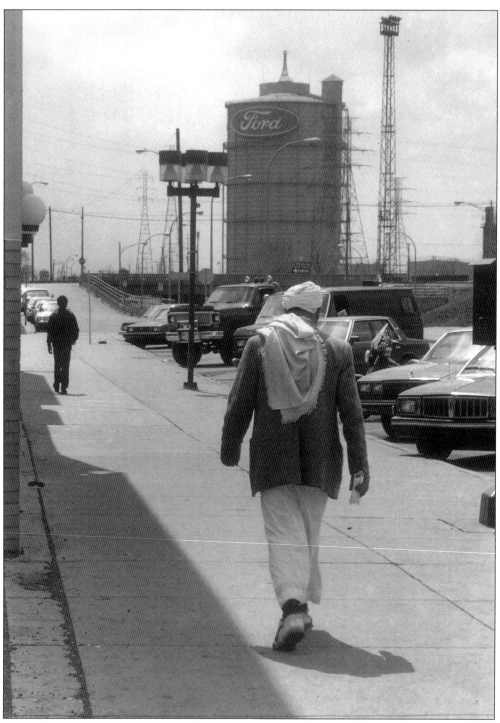

A new Yemeni immigrant is seen walking in the shadow of the Ford Rouge Plant in the South End neighborhood of Dearborn. The South End, a worker reserve, was written up by *Ripley's Believe It or Not* as an area in which 52 different languages are spoken. Today, Arab Americans make up more than 90 percent of the area's population. (Courtesy of ACCESS.)

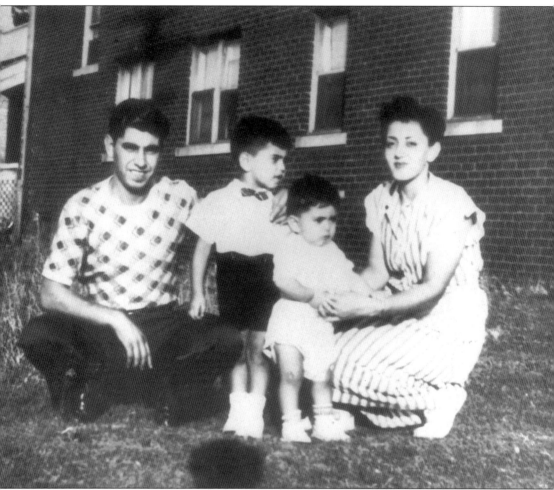

Sam and Katherine Amen and their two older sons Ron and Allen, ages four and two, are pictured at their home in Dearborn around 1950. Both were born in the United States and have lived in Detroit since they married. Sam retired from Ford Motor Company after 42 years of employment. (Courtesy of Sandra Amen.)

This photograph was taken by Saltanah Musaad, who participated in a one-month program sponsored by the Cultural Arts Department of ACCESS during which youth learned to document history through photography. Saltanah's photo, which she entitled "It's Sarah's Turn," was included in the program's 2000 resulting exhibition, *Faces from the Factory*.

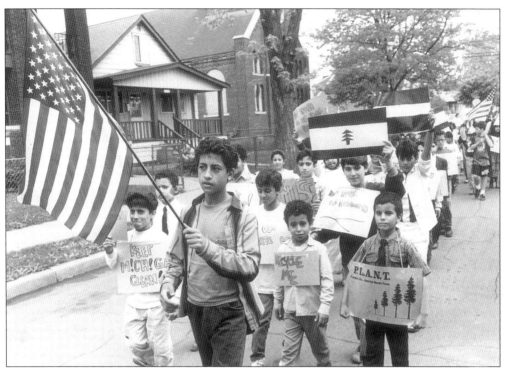

The children of Salina School in Dearborn's South End march in the Salina Clean Up Parade in 1994. (Photo by Bruce Harkness.)

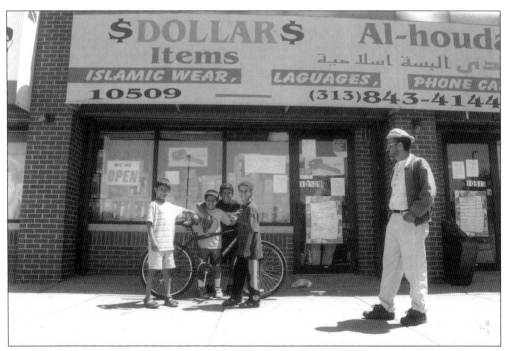

This street scene, of Dearborn's South End, was captured on film in 2001. (Photo by Joan Mandell.)

The Fairway Variety Store, a Lebanese grocer and one of many small businesses on Dearborn's South End, gets a face lift in 1995. In the late 1980s, Arabesque facades were constructed on the businesses of the South End in order to create a recognizable Arab district. (Photo by Millard Berry.)

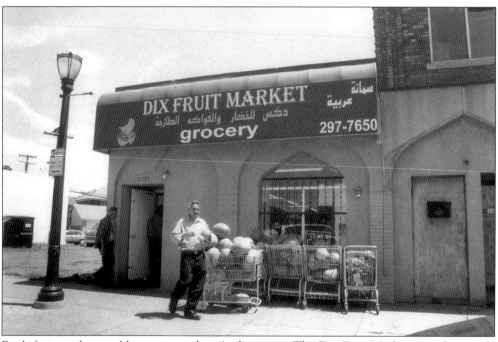

Fresh fruits and vegetables are central to Arab cuisine. The Dix Fruit Market provides a wide variety to the South End community. The weekend is the busiest time for the market when residents of the surrounding neighborhood come to shop, as this photograph in 2001 shows. (Photo by Joan Mandell.)

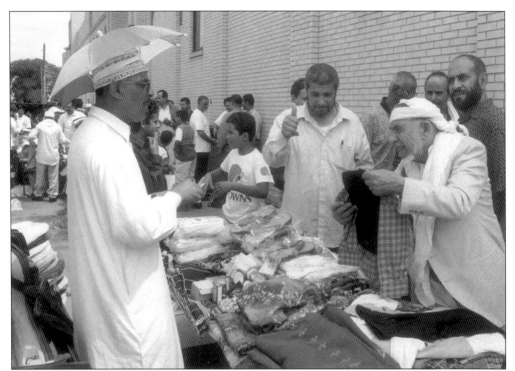

In 2001, Sadeq Nasser sells goods from the back of his car every Friday at the Dix Road Mosque in the South End of Dearborn. (Photo by Joan Mandell)

Old friends enjoy a game of cards at Mustapha Ajami's restaurant and coffeehouse in Dearborn's South End in 1971. Coffeehouses are male domains and important places for male social interaction. (Courtesy of Suzanne Dareini.)

In this 2001 photo, morning domino games are played, at Casino Santiago, a Chaldean club on Seven Mile Road, Detroit. (Photo by Joan Mandell.)

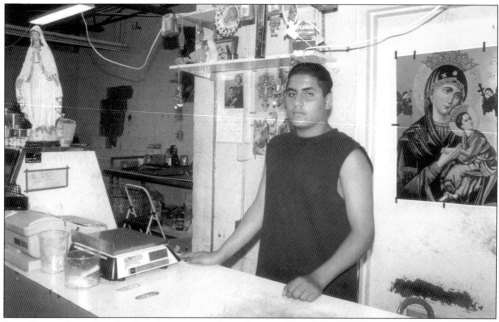

Douglas works at his family's Detroit Food Market in the Chaldean community on Seven Mile Road, Detroit in 2001. (Photo by Joan Mandell.)

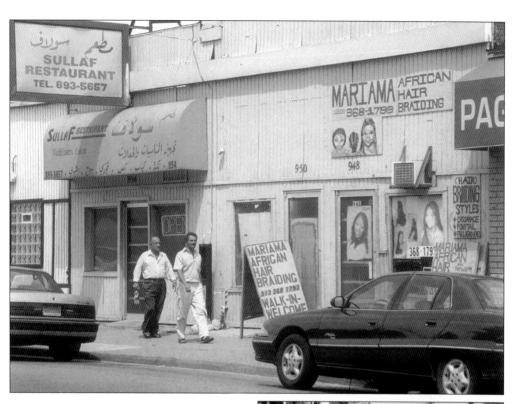

The predominantly Chaldean enclave on Seven Mile Road (Detroit) abuts an African-American district, in this present-day photo. (Photo by Joan Mandell.)

In 2001, Susanna helps her mother, Nedhal Lott, select nuts at the Arabic Town Importers in Sterling Heights, located in the northern reaches of metropolitan Detroit. As the community expands, grocers and other Arab and Chaldean entrepreneurs follow with businesses, making it unnecessary to travel long distances for Arab necessities. (Photo by Joan Mandell.)

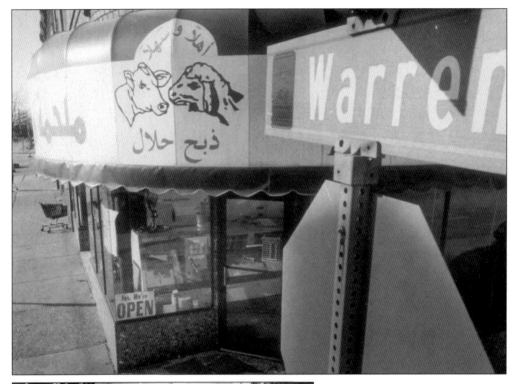

A Warren Avenue halal meat market is located in east Dearborn, the largest concentration of Arab businesses and residences in metropolitan Detroit. (Courtesy of Millard Berry.)

This photograph was taken by Sarah Kluges who participated in a one-month program, sponsored by the Cultural Arts Department of ACCESS, during which youth learned to document history through photography. Sarah's photo, which she entitled "Decisions," was included in the program's resulting exhibition, *Faces from the Factory* in 2000.

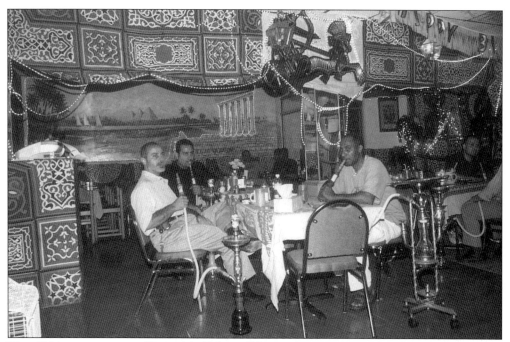

This 2001 image portrays Pharaoh's Cafe on Warren Avenue in east Dearborn, is where men come to eat, smoke *shisha* (water pipes), and listen to music. (Photo by Joan Mandell)

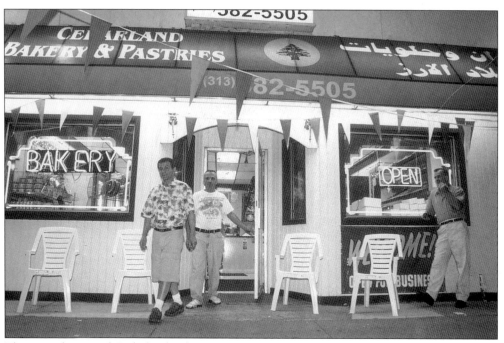

The recently opened Cedarland Bakery on Warren Avenue, Dearborn, is one of many Lebanese pastry makers in the Detroit metropolitan area. This picture was taken in 2001. (Photo by Joan Mandell.)

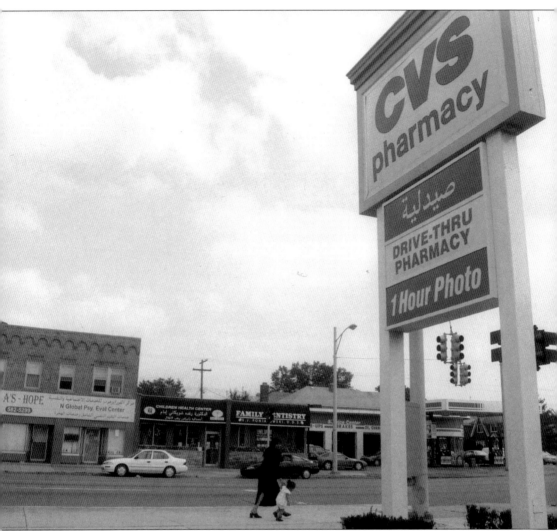

Major American chains, often managed by local Arabs, are also present in Arab enclaves. This CVS on Warren Avenue, Dearborn, caters to Arab-American customers and communicates itself as a pharmacy in Arabic to non-English speakers, as seen in this 2001 photograph. (Photo by Joan Mandell.)

Six
POLITICS

The first serious introduction of Arab immigrants to American politics was during World War I, when young Arab-American men joined the United States Army. In contrast, early Arab immigrants kept a low profile and were rarely involved in American political activities. If at all, they were more concerned about political unrest in their countries of origin. They thought of themselves as migrants who worked to save money and return home.

After the World War I, and as the community settled down and became more established, Arab Americans started to join political parties and labor unions, gradually becoming more involved in local and national politics. The labor movement was one of the most important political activities that attracted Arab Americans, since a large number of them were working in the automobile industry. In the 1930s, George Addes, the son of a Lebanese immigrant from Ohio, gained local and national reputation as a leading labor organizer. He was elected as the Secretary-Treasurer of the UAW-CIO between 1938 and 1947.

In the aftermath of World War II, Arab nationalism was on the rise as countries in the Arab World gained independence. When earlier Arab immigrants were fully acculturated to American culture and fairly involved in local politics, a new wave of Arab immigrants arrived. They brought with them a strong sense of Arab nationalism and activism. Often these immigrants became advocates of their countries' struggle for freedom and democracy, and played a pivotal role in reviving Arab-American ethnic identity. They also helped establish many local and national Arab-American political organizations. Detroit has been the birthplace of many of them.

Currently Detroit's Arab-American community is one of the most organized and active in local and national politics. Issues that most concern the community are discrimination, racial profiling, immigration law, bilingual education, and United States foreign policy towards the Arab World. Arab Americans are active members of the Democratic and Republican parties. They regularly organize voting registration campaigns and have their own candidates for local and national public offices. In 1994, Spencer Abraham, grandson of a Detroit Lebanese immigrant, was elected to the U.S. Senate. Currently, he serves as Secretary of Energy in the Bush administration.

Detroit's Arab-American community has emerged as a strong political and voting force. During the 2000 presidential elections, the community drew national attention, when both the Democratic and Republican parties sought their support.

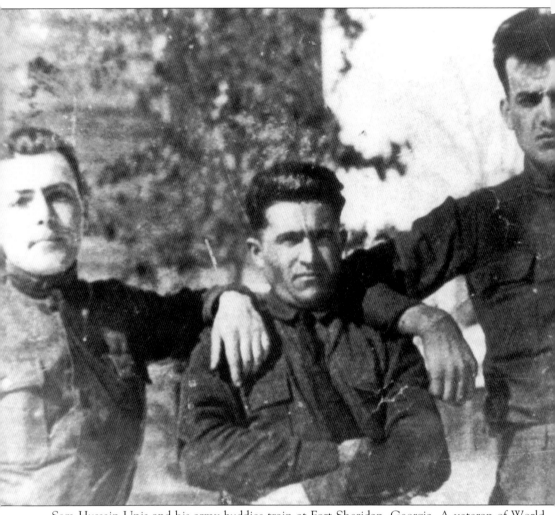

Sam Hussein Unis and his army buddies train at Fort Sheridan, Georgia. A veteran of World War I, Sam was drafted only four months after he arrived in America in 1917. Immigrants who served in the war were given U.S. citizenship. (Courtesy of Don Unis.)

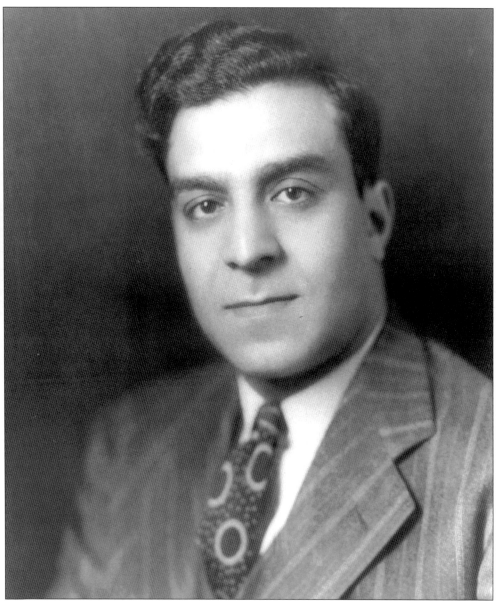

George A. Addes, the grandson of a Lebanese immigrant, was born in La Crosse, Wisconsin, in 1910. George became one of the most respected and influential union leaders during the 1930s and '40s. When his father, a railroad firemen, became sick and unable to work, George, at the age of 17, found himself forced to leave school to support his family. He found a job as a wet-sander at 65¢-an-hour, but immediately started organizing workers, demanding better pay and working conditions. Addes emerged as one of most talented organizers. By 1936, Addes was elected as the first Secretary-Treasurer of the powerful UAW-CIO, and he was re-elected ten additional terms until 1947. Under his leadership, the UAW grew from less than 30,000 members to over half-a-million. He also became famous for his ability to maintain the UAW's unity at a time when division of the UAW seemed inevitable in the late 1930s. Addes died in St. Clair Shores, a suburb of Detroit, in 1979. Both his daughter, Joyce Chaffee, and his granddaughter, Renee Carrigan, work at the UAW Solidarity House in Detroit.

The International President of the United Auto Workers, Stephen P. Yokich, a son of a Lebanese mother, addresses a rally in front of the Detroit News building in support of newspaper workers' strike, 1996. (Photo by Rebecca Cook.)

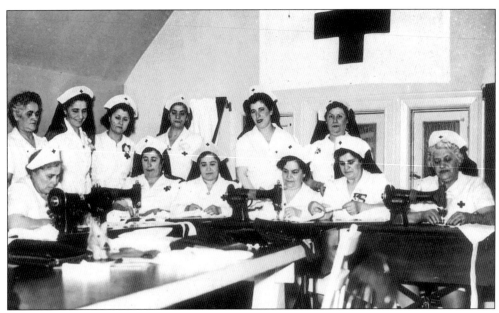

Members of the Ladies Society of St. Maron Church are captured on film, volunteering at the Red Cross in 1943. The St. Maron Church was among the first Arab churches in Detroit, built in 1897 on the east side of downtown Detroit on St. Aubin and Larned. The women, as is the case with other religious and social Arab-American institutions, are usually the most active in the church's fundraising and social activities. (Courtesy of Raquel Abud Ahee.)

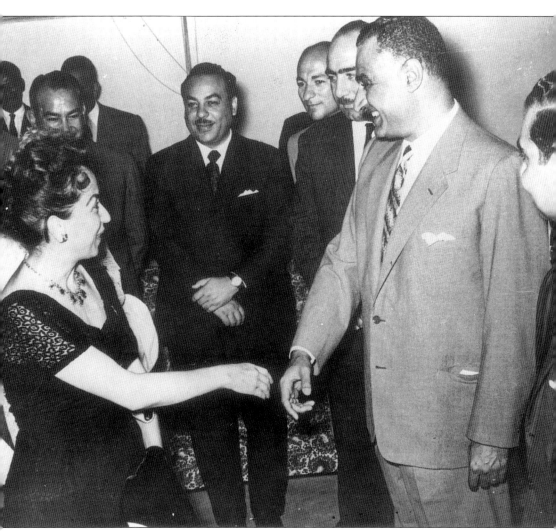

Aliya Hassen, a feminist and political and community activist, leads a group of African-American leaders on a trip to Egypt. At the time, the Egyptian President Jamal Abdel Naser was considered the indisputable leader of Arab and African nationalism. These nationalist movements inspired many Arabs and African Americans.

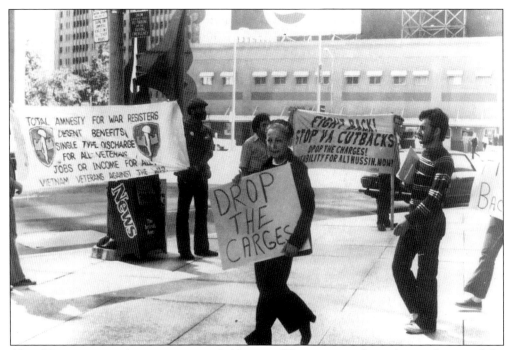

Aliya Hassen is seen demonstrating with Vietnam War veterans about the conditions of the Veterans Administration hospitals in Detroit.

Flag-waving students turn out for a "Clean-Up-Our-City" rally in Dearborn in 1994. (Photo by Bruce Harkness.)

INTELLIGENCE
INTEGRITY
DIGNITY

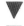

A MAN OF COURAGE...
WHO DARES TO BE DIFFERENT

VOTE TUESDAY, AUGUST 4TH ... BOARD OF COMMISSIONERS ... 5TH DISTRICT ... VOTE TUESDAY, AUGUST 4TH

BOARD OF COMMISSIONERS 5TH DISTRICT

5TH DISTRICT BOARD OF COMMISSIONER

We need to re-establish the faith, trust, and confidence of the people in their public servants. We need men of integrity, courage, and ability to insure efficient government, equal government, and honest government.
I am prepared and willing to devote the rest of my life to these ideals in public service.

Joseph L. Barakat Age 34
1558 Dulong, Madison Heights, Michigan 48071 (313) 545-1871

EDUCATION
Henry Ford Grade School Highland Park, Michigan
Highland Park High School Highland Park, Michigan
Graduate, Army Engineering School Ft. Belvouir, Virginia
B.A. Degree Major - Political Science Minor - Psychology W.S.
Graduate Study, University of Michigan Ann Arbor, Michigan
M.A. Degree Major - Political Science International Relations*

MILITARY EXPERIENCE
United States Air Force 4 Years Active Duty
 2 Years Reserve

Surveying & Computing for Ballistic Missiles
N.A.T.O. Top Secret Clearance – Honorable Discharge

This is Joseph (Yusif) Barakat's campaign brochure from 1974. Barakat was among the earliest Arab Americans to run for public office. Today, Arab Americans are involved in both local and national political events.

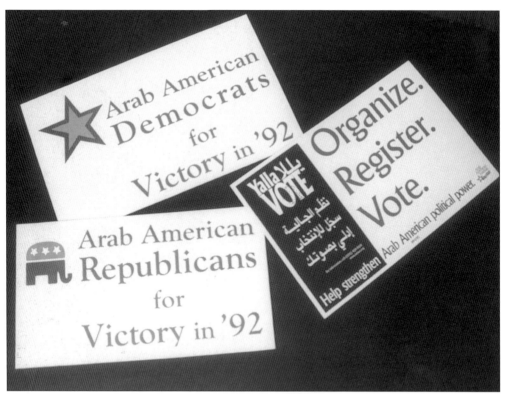

Here is a sampling of political posters by Arab Americans.

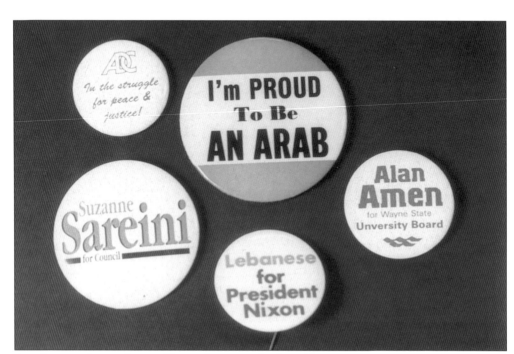

Another sampling is depicted here, this time of political buttons.

Amal Berry shows support for gubernatorial candidate Howard Wolpe at the Michigan Democratic Convention in 1994. (Courtesy of *Flint Journal*, photo by Bruce Edwards.)

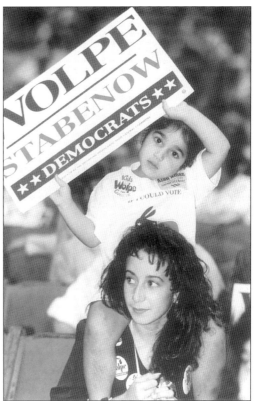

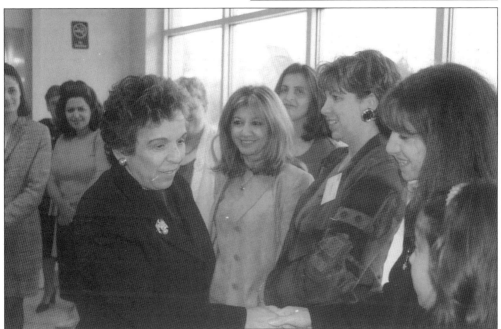

Donna Shalala, Secretary of Health and Human Services during the Clinton Administration, is seen here meeting with Arab-American women during the 2000 elections. Many national and local candidates solicited Arab votes during this local and Federal election.

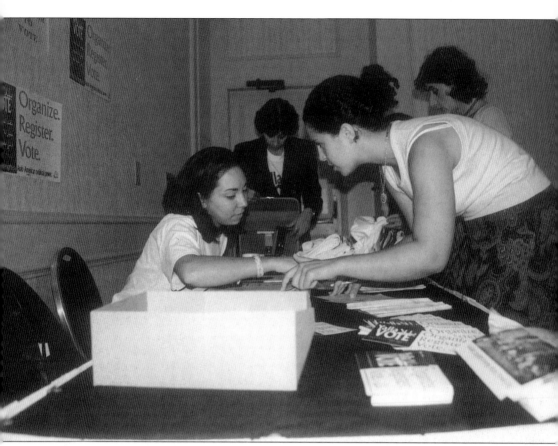

This 1998 voter registration drive in Dearborn was organized by the Arab American Institute. The AAI was founded in 1985 and has its national office in Washington D.C. The AAI promotes Arab-American involvement in political processes, supports local and national Arab-American candidates, and organizes voter registration campaigns. (Courtesy of the AAI.)

Karim Khalaf, the mayor of the Palestinian city of Ramallah, is shown at the American Ramallah Federation's convention in Detroit in 1974. Present in the picture are all the Federation's presidents except for one. The Federation's founding convention was held in Detroit in 1959. Metro Detroit is the home of the Federation's national office, and more than 5,000 people (30,000 nationally) who trace their roots to the city of Ramallah, Palestine.

Detroit's Mayor Coleman Young and Dr. Elaine Hagopian, a founding member of The Arab American University Graduates (AAUG), participated in the tenth annual convention in 1977. Detroit is the birthplace of a number of national Arab-American organizations, including the AAUG.

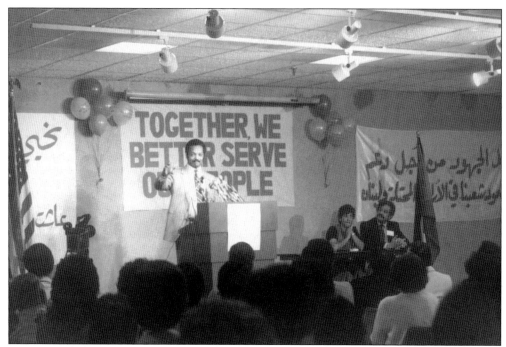

Reverend Jesse Jackson is seen addressing the Palestine Aid Society of America convention (PAS), a national organization that was founded in 1984 in Detroit, Michigan.

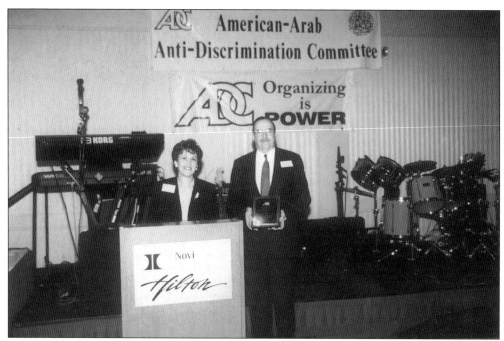

In 1998, Wafa Salah, president of the American-Arab Anti-Discrimination committee gives an award to Father William Gepford of the Little Field Church in appreciation for his support to the Arab-American community.

This is a fundraiser at the Christ Church in support of a church in Nazareth. The Christ Church, with a large number of Syrian-American members, has been a longtime supporter of the Palestinian-Christian community in Nazareth. Although the community has moved to the suburbs—mainly Grosse Pointe and St. Clair Shores—many continue to attend the Christ Church in downtown Detroit. The photograph is from 1974. (Courtesy of Josephine Zedan.)

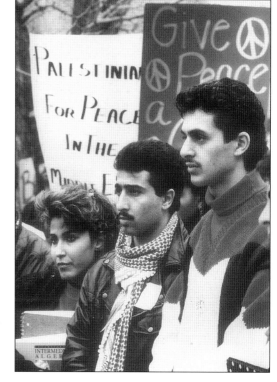

Arab-American students at the University of Michigan, Dearborn, protest the Persian Gulf War in 1991. (Photo by Millard Berry.)

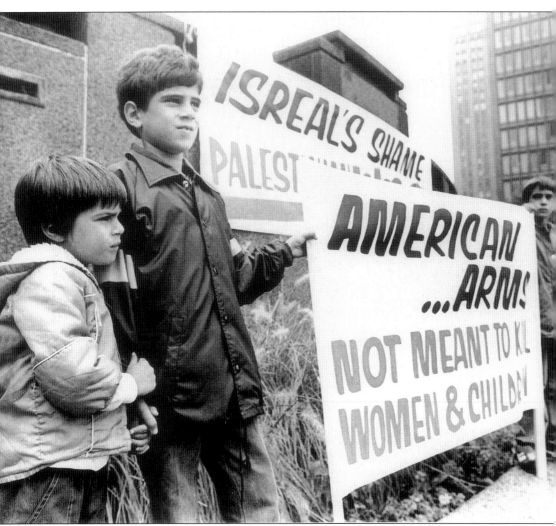

Three brothers stand solemnly in Detroit's Kennedy Square at a memorial service for the hundreds of Palestinian refugees killed in Lebanon in 1982. Holding a sign protesting U.S. military support of Israel, pictured from left to right, are: Mohed Rahmen, age five, and his brothers, Nabil, age eight, and Zeyad, age nine, of Dearborn. They were among an estimated 500 members of the Detroit-area Arab-American community who took part in the 75-minute ceremony, during which hundreds of white carnations were left near the boys as an expression of sympathy for the dead. The rally was sponsored by the Islamic Center of Detroit. (Courtesy of *Detroit Free Press*.)

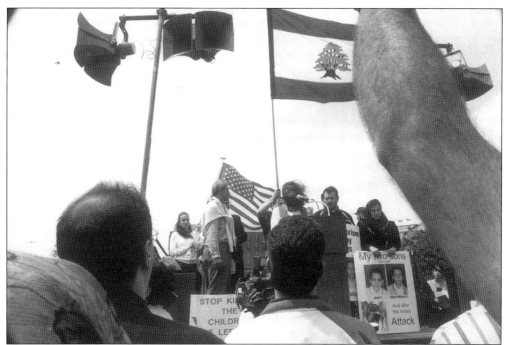

A Washington D.C. rally organized by Arab Americans from Detroit protested the Israeli bombing of Qana shelter in south Lebanon in 1997. (Photo by Haajar Mitchell.)

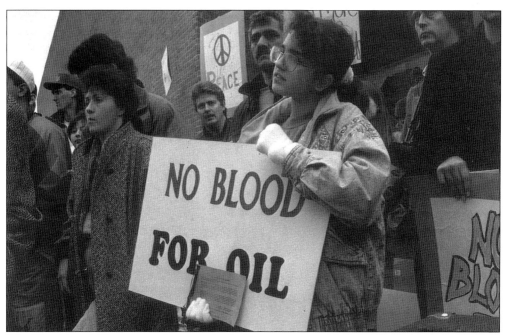

"No Blood for Oil" is among the signs Arab Americans carried demanding an end to the Gulf War at this Dearborn demonstration in 1991 (Courtesy of Joanna Al-Hajj.)

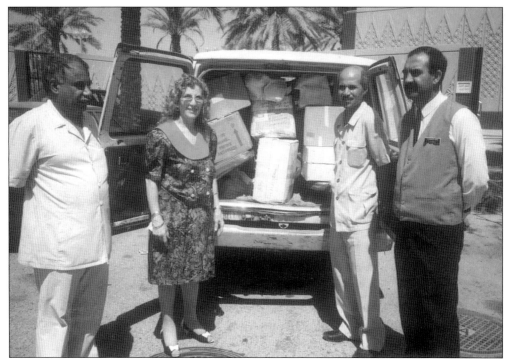

Dr. Nathmia Atcho, an Iraqi American from Detroit, prepares to leave Amman, Jordan, for Iraq, a van filled with donated medical supplies and educational materials from the National Arab American Medical Association Foundation. (Courtesy of NAAMA.)

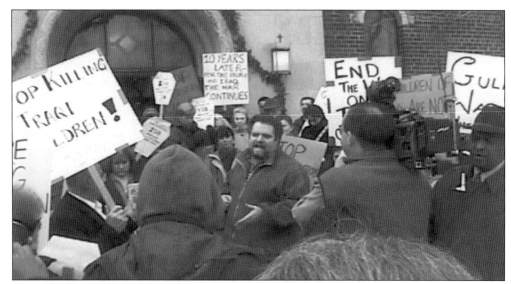

A 2001 rally in Detroit commemorating the tenth anniversary of the Gulf War was organized by "The Committee to End Sanctions Against the People of Iraq." Detroit is the home of a large Iraqi community. While the majority of Iraqis in the Detroit area have been Chaldeans, a larger number of both Muslims and Christians have been coming to Detroit since the Gulf War. Most of them continue to send money, clothing, and medical supplies to family members and relatives they left behind. (Photo by Eric Borregard.)

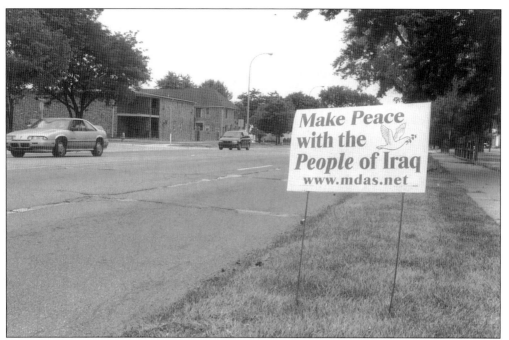

This is a sign in front of a home on 14 Mile Road in Birmingham in 2001. (Photo by Joan Mandell.)

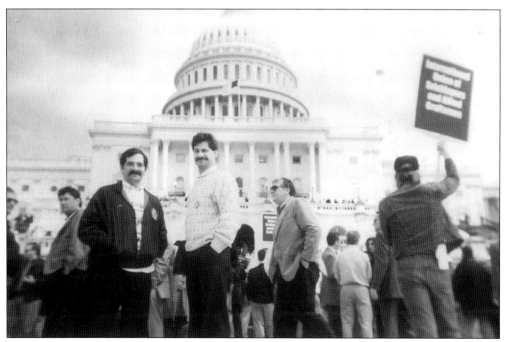

Joe Abdoo, president of the International Brotherhood of Electric Workers, Local 58, is seen leading Detroit's delegation to protest the attempts by U.S. Congress to repeal the Davis-Bacon Act, a pro-union federal law in 1994.

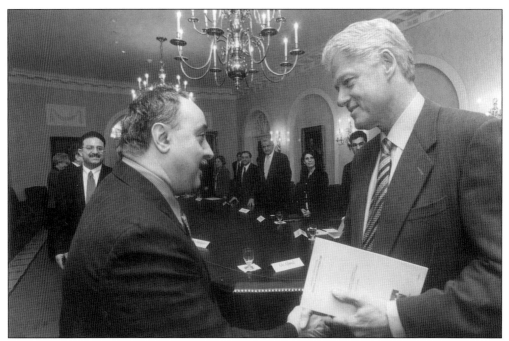

ACCESS Executive Director Ismael Ahmed discusses welfare reform and immigration matters with President Bill Clinton in 1995.

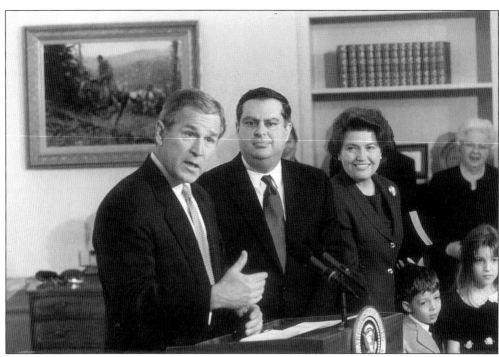

Secretary of Energy Spencer Abraham (a former U.S. Senator) is the grandson of Lebanese immigrants and resident of Dearborn.

Seven

PRESERVING CULTURE

When Arab immigrants began coming to the United States in the late 1800s, they were a very small minority. They lived in their own ethnic enclaves on Detroit's east side and the downtown area, remaining fairly isolated from the American mainstream. However, their children, who attended public schools, felt pressure to be American. At this time, it was understood that to be a "true" American meant to abandon one's native language and traditions and embrace the American lifestyle. A considerable number of immigrants, including Arab Americans, changed their names and style of dress in response to this pressure. Many spoke their native language and consumed traditional foods only within the confines of their own homes. Others, however, resisted Americanization and struggled to preserve their identity and culture. For example, Arabs built their own institutions, including social clubs, churches, and mosques, and established Arabic language newspapers, radio shows, and classes to teach their children Arabic.

More recent immigrants from the Arab World have had an easier time preserving their cultural identity. Today, new immigrants arrive in Detroit where there are well-established Arab-American communities. They also tend to have stronger ties with their country of origin. Many second and third-generation Arab-American children are reclaiming their Arab-American heritage, which is expressed in their art, music, and literature, and the national institutions they have built to address the needs and concerns of Arab Americans. Arab cultural performances and workshops are important parts of the annual events calendar in the Detroit metro area. Occasions at public and private venues throughout the area range from art exhibits and henna demonstrations to poetry readings, political meetings, and musical recitals. The fact that ethnic and cultural diversity is becoming more widely accepted in the United States has encouraged Arab Americans to preserve their ethnic identity and cultural heritage.

THE SYRIAN ORTHODOX CLUB OF DETROIT

النّادي السُّرْيَانِي الأَرْثُـودُوكْسِيُّ فِي دِيتْرُوِيْتْ

in appreciation for their efforts in supporting the syrian community and for keeping our inherited traditions and customs as they were held by our ancestors and for guiding the generations to follow in their spirit we give this declaration to :

DIB ABDALLA

تقديراً للجهود المشكورة في تدعيم الجالية السورية وفي حفظ التراث والتقاليد الموروثة عن الآباء والأجداد ولكي ينهج الأبناء نهج الآباء اعطيت هذه اللوحة التذكارية

president: George Gray

secretary: George Woms

date: JULY 1, 1978

A 1978 certificate from the Syrian Orthodox Club of Detroit recognizes the contribution of Dib Abdalla in preserving Syrian culture in the United States. Arab-American social and religious institutions emphasize the importance of preserving culture. Members of these organizations organize Arabic language and history classes, picnics, plays, and folk dances that are geared to teach the culture and instill ethnic pride, especially among younger generations. (Courtesy of Marie Abdalla.)

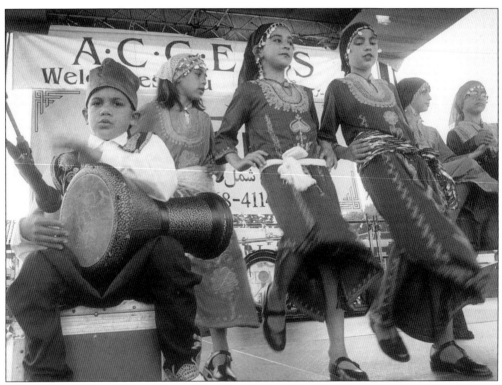

The Arabic Folkloric Dance Group from Iris Becker School performs at a festival on Warren Avenue in 1996. (Photo by Millard Berry.)

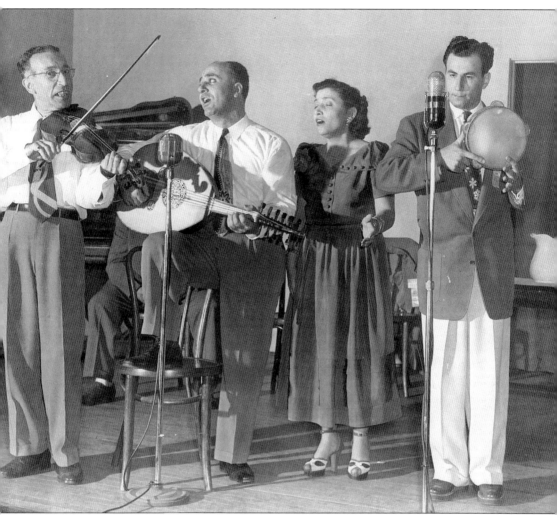

Detroit can boast of a long and dynamic Arab musical culture that continues to thrive. Sana (singer) and Amer Kadaj (with tambourine) were very active in the Detroit scene in the 1950s. They left Palestine for the United States in 1947, never intending to stay, but were forced to remain due to the fighting there. They developed a successful musical career in Detroit and were cherished by Arab Americans throughout the United States. (Courtesy of Lila Kadaj.)

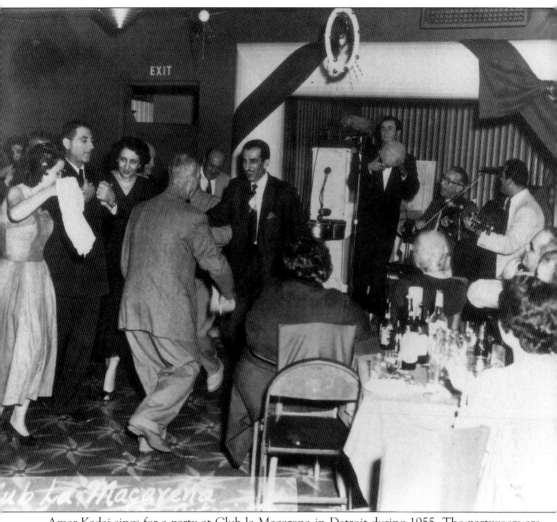

Amer Kadaj sings for a party at Club la Macarena in Detroit during 1955. The partygoers are dancing the *debkeh*, a line dance which is performed in different local or national styles with a wide range of individual embellishment and heartfelt enthusiasm. (Courtesy of ACCESS.)

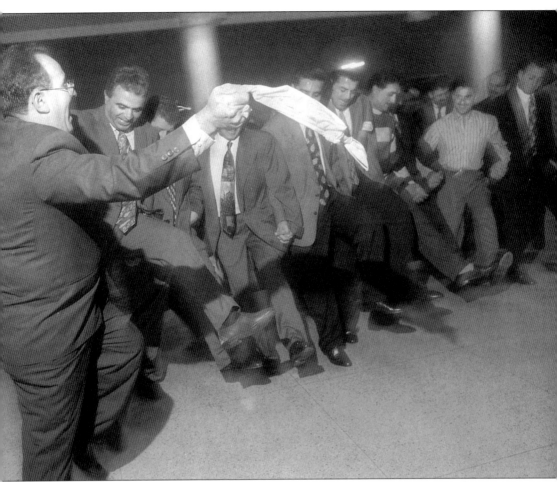

Energentic dancers perform the *debkeh* at a community fundraiser in Livonia, Michigan, in 1995. (Photo by Millard Berry.)

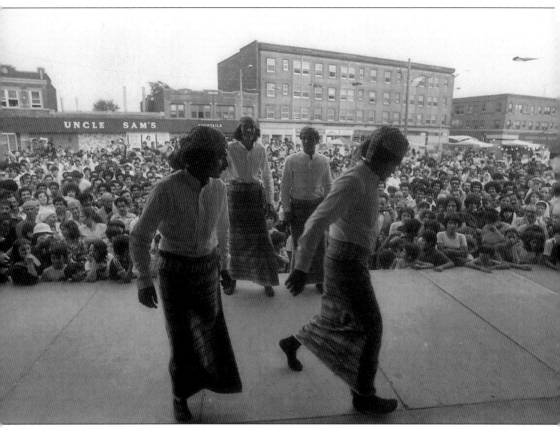

A Yemeni dance troupe performs at the Dix Festival in 1979. Choreographed dances by amateur groups exist within most ethnic groups. While they educate outsiders about a group's culture, more importantly they help to maintain some semblance of traditional dance and music within the community itself and among the youth. (Photo by Millard Berry.)

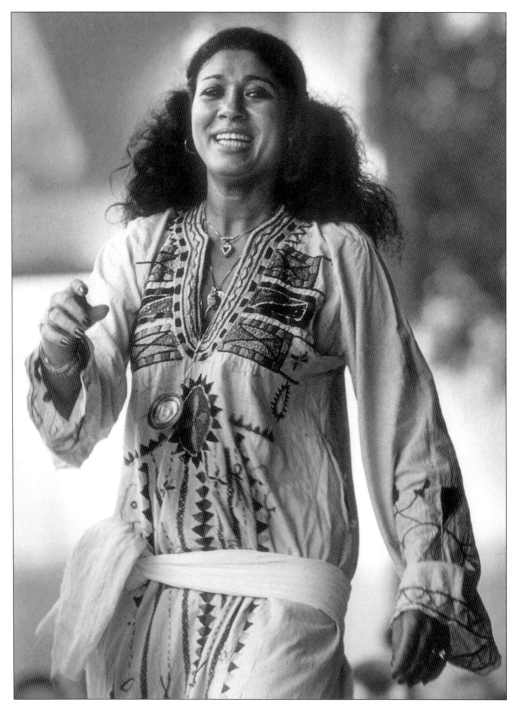

An Arab-American woman dances in an Egyptian costume at the Dix Festival in 1979. (Photo by Millard Berry.)

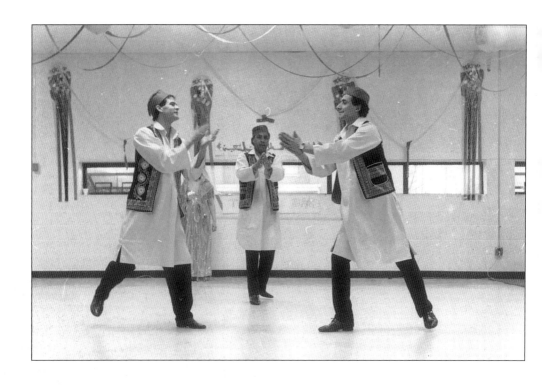

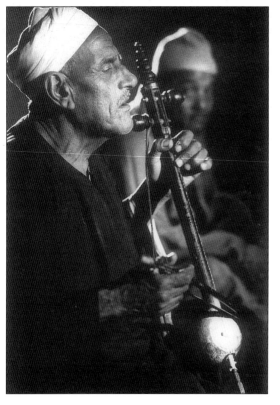

Arab Americans often bring dance and music groups from Arab countries. Egypt has been one of the main cultural centers in the Arab world. In these pictures an Egyptian dance troupe (top) and Sheik Ghanem Mansour, Egyptian traditional storyteller, plays the *rababa* and recites stanzas from the Bani Hilal epic (bottom), during the early 1990s. (Photo by Millard Berry.)

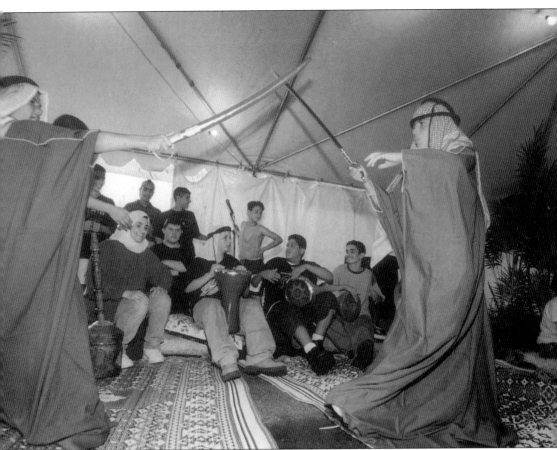

Youth at the Dearborn International Festival are playing with swords, dressed as Bedouins, with the head cover and *abaya*, a traditional men's coat made of camel hair. This tent is furnished with rugs on the ground and low benches covered with rugs around the inside perimeter. It is always filled with community members who watch performances such as this, sing to the accompaniment of musicians, and drink Arabic coffee served by the local merchants who put up the tent. This image is from 2001. (Photo by Bilal Mokdad, courtesy of the American Arab Chamber of Commerce.)

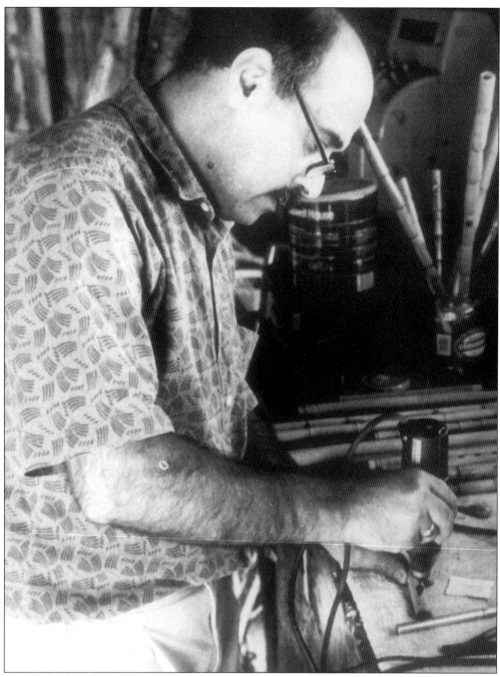

Nadim Dlaikan burns finger holes into a *nye* in his garage workshop in 1994. A *nye* is a single reed, end-blown Arab flute. Nadim is a 1994 Michigan Heritage Awardee, recognized for his virtuosity as a *nye* player and his outstanding efforts in maintaining traditional Arab music. A *nye* player requires at least a dozen different flutes, because each *nye* is capable of only one key, and Arab music with its many quarter and half tones contains many keys. Since his arrival in Detroit, Nadim has made *nyes* for Arab musicians around the country, with bamboo reeds he grows in his backyard. (Photo by Sally Howell, courtesy of ACCESS.)

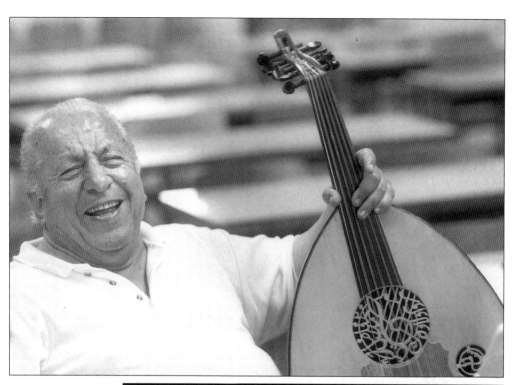

Iraqi-American *oud* virtuoso, Abdul Karim Badr, enjoys a concert of Arab classical music in 1994. (Courtesy of Millard Berry.)

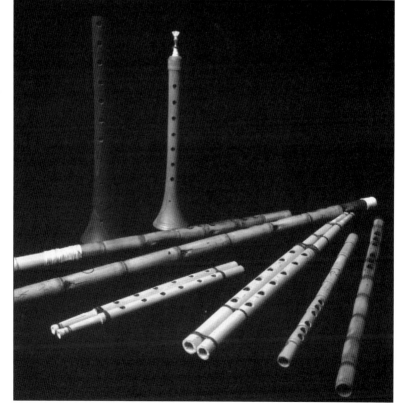

Arab flutes (*mizmar*, oboe-like double reed; *nye*, single reed; *mizwij*, single reed double flutes) that are made by virtuoso *nye* player Nadim Dlaikan are shown here.

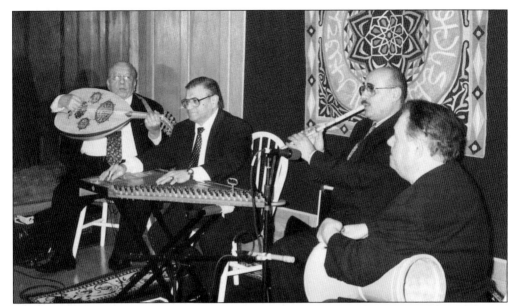

Nadim Dlaikan and friends perform traditional Arabic music at the gala opening of the exhibition, *A Community Between Two Worlds: Arab Americans of Greater Detroit*, that was held in East Lansing, Michigan, in 1999. They are Abdul Karim Badr (*oud*), Johnny Sarwah (*qanun*, plucked zither), Nadim Dlaikan (*nye*), and Osama Naja (*tabla*). Musicians in Arab Detroit are valued as culture brokers, and as such, they direct audience participation in gatherings such as weddings, engagement parties, baptisms and circumcisions, and graduation parties. They must be able to play traditional, classical, and popular music from all parts of the Arab World. In this context, a hybrid musical sound has evolved that is very popular in the Arab community. Older classical and folk music are becoming rare and treasured. As a defender of traditional music and song, Nadim Dlaikan is often called upon to pull together an ensemble to present classical and traditional Arab music. (Photo by Marsha MacDowell, courtesy of the Michigan State University Museum.)

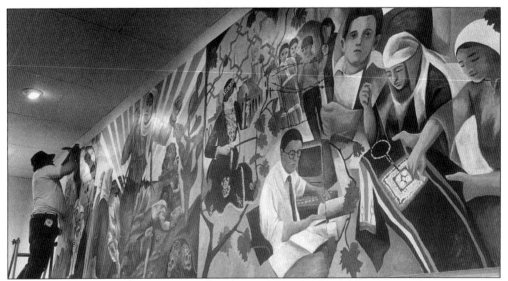

This mural at ACCESS' main office is by the late Palestinian-American artist Seri Khoury. The mural reflects scenes of daily life in Palestine. (Courtesy of ACCESS.)

This wall hanging of the Lord's Prayer in Arabic was cross stitched by Irene Harb and is an example of the handiwork present in the Detroit community. It conveys blessings and reminds the family of their Greek Orthodox faith. (Photo by Mary Whalen, courtesy of Michigan State University Museum.)

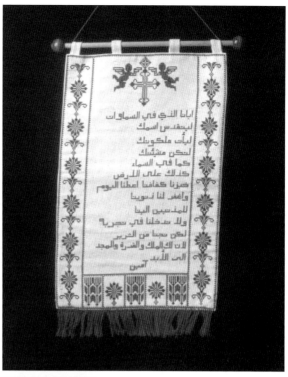

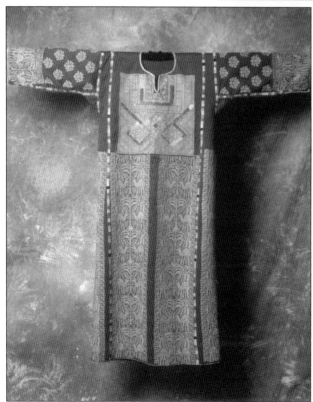

A Palestinian dress (*thob*) designed by Halimah AbdelFattah is shown in this photograph. Halimah is from the village of Beit Hanina, and she and many other women over 40 still wear handmade *thobs* and headdresses adorned with multiple rows of gold coins, to weddings, engagement parties, and gatherings celebrating births and graduations. Today, more and more women are purchasing their dresses from Palestinian refugees or have machine-couched dresses made for them. With its camels and palm trees, this *thob* is a modern version of a traditional Palestinian *thob*, nonetheless it is handmade as are all of Halima's dresses. Once a village tradition, the *thob* has become an internationally recognized symbol of the Palestinian nation. (Photo by Mary Whalen, courtesy of Michigan State University Museum.)

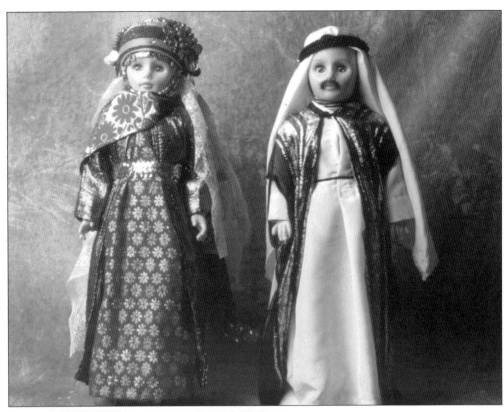

Chaldean dolls made by Henniya Shawine are shown here dressed in wedding attire. These dolls have come to represent Chaldean identity. In Detroit, these dolls are given to brides and expectant mothers, and are displayed in homes and places of business as a sign of ethnic pride. A delegation of Chaldean Democrats expressed this pride when they gave one of these dolls to Bill Clinton during his 1996 campaign. (Photo by Mary Whalen, courtesy of Michigan State University Museum.)

Iraqi-American artist Mohammed Fradi participates in an exhibit for Arab-American artists in Dearborn in 2001. Mr. Fradi is one of many Iraqi artists who arrived in the Detroit area in the 1990s. Their presence has reinvigorated artistic life in the Arab-American community. (Photo by Joan Mandell.)

Nabil Bamyeh (played by Ed Nahhat) receives his first piece of marital advice from his future father-in-law Magdi Ganzari (played by Kam Kewson) in a scene from the play *The Marriage Proposal* by the Arab Theatrical Arts Guild (ATAG). The play is produced and directed by Ray Alcodray, who is also the founder of ATAG. Detroit is an important city for Arab-American theatre. Plays have addressed the immigrant experience, including issues of Americanization, crime, drugs, and preserving family and cultural values. They are in English, Arabic, or an Arabic-national dialect. (Courtesy of ATAG.)

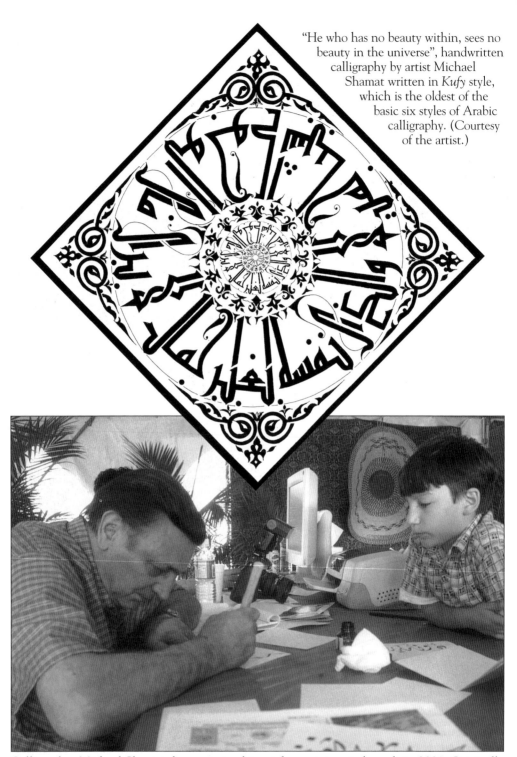

"He who has no beauty within, sees no beauty in the universe", handwritten calligraphy by artist Michael Shamat written in *Kufy* style, which is the oldest of the basic six styles of Arabic calligraphy. (Courtesy of the artist.)

Calligrapher Michael Shamat demonstrates his art for an interested youth in 2001. Originally used for writing religious texts, calligraphy now is used to convey religious messages and embellishes on buildings, signs, rugs, glassware, etc. (Photo by Joan Mandell.)

For special occasions, such as weddings and religious holidays, Arab-American women decorate each others hands and feet with intricate patterns in Henna. Henna is a dye made from the leaves of the Henna plant. It is used to color hair and create temporary tattoo-like designs on the skin. Henna adornment is now very popular with the general American female population and many beauty shops offer Henna application as one of their services.

Artist Christina Assaf instructs a child about painting a mural depicting the evolution of Arab-American women's lives, in 2001. (Courtesy of ACCESS.)

An Arab-American child demonstrates his ability on the tambourine. On occasion ACCESS supports apprenticeships as a way to support and reinforce the continuity of traditional arts.

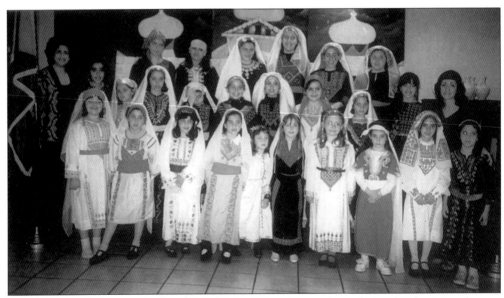

Young girls, representing the Ramallah Club of Detroit, pose in traditional Palestinian dresses. Few women and children of Detroit dress in traditional clothing today, except on special occasions and for choreographed dance performances. (Courtesy of Karim Ajluni.)